THE ART AND BUSINESS OF PHOTOGRAPHY

SUSAN CARR

ALLWORTH
PRESS
NEW YORK

15 14 13 12 11 5 4 3 2 1

Published by Allworth Press
An imprint of Allworth Communications, Inc.
10 East 23rd Street, New York, NY 10010.

Everything is Free
Words and Music by Gillian Welch and David Rawlings
Copyright © 2001 IRVING MUSIC, INC., SAY UNCLE MUSIC and CRACKLIN' MUSIC
All Rights for SAY UNCLE MUSIC Controlled and Administered by IRVING MUSIC, INC.
All Rights for CRACKLIN' MUSIC Controlled and Administered by BUG MUSIC
All Rights Reserved Used by Permission
Reprinted by permission of Hal Leonard Corporation

Cover and interior design by The Grillo Group, Chicago, IL
Cover photograph by Susan Carr, Chicago, IL
Page composition/typography by Sharp Designs, Lansing, MI

ISBN: 978-1-58115-759-8

LIBRARY OF CONGRESS CATALOGING-IN-PUBLICATION DATA
Carr, Susan, photographer.
The art and business of photography / by Susan Carr.
p. cm.
Includes bibliographical references and index.
ISBN 978-1-58115-759-8
1. Photography. 2. Photography—Practice. 3. Photography industry. I. Title.
TR154.C45 2010
770.68—dc22
2010042756

Printed in Canada

For my parents

CONTENTS

PART I: ART AND COMMERCE

The passion to pursue photography is shared by many; pushing that drive to an art is less common. This introductory chapter looks at this distinction and its importance to the contemporary working photographer.

A fast-paced review of the history of photography through the lens of commerce and career profiles of Sean Kernan, Richard Kelly and Susan Carr. By looking at how various photographers have made a living, the critical connection of the independent artist and a method for monetizing artistic skills is revealed.

Photographers need to separate client and personal work in order to successfully find genuine artistic expression. This chapter discusses how by integrating personal work into a business, both are strengthened.

PART II: A REALISTIC LOOK AT THE INDUSTRY

This realistic look at the state of our industry concisely explains photography's dramatic and rapid change by highlighting the shifts in how advertising and media markets function. This look at the recent past provides insights for future solutions.

An outline of business musts: copyright, licensing, releases, pricing, business management, marketing and sales. Each category is discussed in detail and a list of resources is provided.

This chapter articulates what craft is to the photographer and its critical connection to making art and building a successful business. The experiences of various photographers are shared and a resource listing for improving craft is provided.

Fostering creativity: mindful time, persistence, and openness. This chapter outlines each of these steps and provides a list of resources to help.

Redefining the role of the photographer.

ACKNOWLEDGMENTS

Writing this book taught me the power of collaboration. As much as I am resolute in my encouragement of photographers to find a unique and individual voice, I am equally passionate about the need for community and it is mine that made this book possible.

First and foremost, I want to thank Richard Kelly and Sean Kernan for their willingness to candidly share their personal stories and photographs. Their selfless contributions enrich this work. Thank you to Tad Crawford of Allworth Press for his support in bringing this dream to fruition. My appreciation to Maria Grillo and Gabrielle Schubart of The Grillo Group for their beautiful design work and supportive patience. A special thank you to Gary Cialdella who served as my loyal reader and trusted counsel throughout this project.

Many of my photographer colleagues and business associates have contributed to this book; from provocative conversations about where our industry is headed, to the sharing of insights and knowledge, to encouraging words and sage advice, these people are part of this work. Richard Anderson, Leslie Burns, Blake Discher, Shannon Fagan, John Giammatteo, Shawn Henry, Judy Herrmann, Todd Joyce, Jay Kinghorn, Bruce Kluckhohn, Peter Krogh, Paula Lerner, Gail Mooney, Eugene Mopsik, Victor Perlman, Stanley Rowin, Jeff Sedlik, Rosh Sillars, Jane Stimmler, Mary Virginia Swanson, Barry Schwartz, and Thomas Werner.

My love and thanks goes out to my family and friends for their steadfast support. A special thank you to my sister Bonnie Niemann for the research assistance only a librarian can provide;

to Nancy Marttila for taking care of my dog when I travel and sending me home with days of meals to keep me going; to Brian Agne for being my grammar expert; and to my dog park gang and their dogs who together frequently provided needed comic relief on long marathon writing days.

PREFACE

To find your calling is a gift. A purpose provides the drive to pursue excellence along with an unwavering belief that your work is of value. When you can take this resolve and turn it into a vocation you achieve a rare and extraordinary feat.

Professional artists know, at some level, how lucky they are. No one will deny, however, that this is an extremely difficult time to be an independent working photographer. The fees paid for our services have dropped, costs have increased, and the number of photographers has exploded; yet, we persist. This persistence to start or maintain careers in this industry that I see in so many of my colleagues inspired me to write this book. I hope to provide the information and practical resources necessary for photographers to find the delicate balance of art and business.

I moved to Chicago from Kalamazoo, Michigan, in 2005. The decision to leave my home of twenty-four years was difficult, but the turmoil of the state's business climate forced me to make a choice: stay and seek alternative employment or find a way to continue my career as a photographer. The two had become mutually exclusive and I had to decide. I chose, not for the first time, to be a photographer.

Geographic moves are strange occurrences. Few acts are more disruptive—the task of shutting down one household and setting up another is exhausting—yet few things are filled with more possibilities of renewal and hope. It took a number of months for me to feel even remotely at home in my new city. It took even longer for me to pick up a camera when I was not being paid to do

so. Yet when I did start photographing again, I felt connected and inspired. Photography was again providing me an anchor and a purpose.

I am a professional photographer. I am also a past president of the American Society of Media Photographers (ASMP) and currently working part-time for the ASMP Foundation as Education Director. These combined activities have made me a participant and a witness to an era of extreme volatility in the business of being a photographer.

In the short span of my career, the method I use to create images changed from film capture to pixels, delivering work moved from hard copy to electronic transfer, customer use transitioned from offset printing to digital printing and is now dominantly online, and publishing is shifting from paper to electronic devices. Additionally, my images can now be easily duplicated with no loss of quality and my cameras need replacing every few years rather than every few decades.

This evolution presents working artists with both challenges and opportunities. The flip side of the ease with which someone can take my images off a Web site is that I now can publish my own work online and reach audiences I never would have found in the past. The Internet offers small businesses more affordable ways to compete, and while the marketing budgets of these new smaller entities don't compare to those of the old economy, there is opportunity here if we can find a way to monetize small Internet uses of our work. While the expense and learning curve is steep to keep up with new digital technologies, the tools now readily available in multimedia and video open up new presentation formats and marketable services. The very definition of photography expands to include sound and moving images.

The pace of change impacting the professional photography industry is mind-boggling. Since late 2008 when I conceived the idea for this book, over 400 magazines have closed their doors,[1] 25 percent of newspaper jobs in the United States have been cut,[2] Facebook has over 400 million users,[3] Twitter reports an average of 55 million tweets per day,[4] digital single lens reflex cameras now

offer video capability, and the iPad was introduced. Additionally, Google settled a lawsuit filed by authors and book publishers paving the way for a royalty payment system for online uses and the American Society of Media Photographers, after being denied access to this settlement's class, filed its own suit against Google.

While writing this book I grew increasingly anxious as seemingly every day a new article or book reveals another insight or obstacle related to the future of our industry. I have tried vainly to keep up with it all, feeling pressed to incorporate every new fact or idea. Through the counsel of colleagues, I came to realize that finite conclusions are impossible as our industry's evolution is ongoing. The changing specifics of contemporary issues will undoubtedly alter some conclusions drawn in this book, so I must rely on the reader to continue exploring where photography is headed and what that means both collectively and individually. My hope is that by offering an understanding of why the business of photography has changed, while simultaneously pinpointing the fundamental artistic and business basics that still hold true, I can point a way for photographers to shape their own unique careers.

PART I

ART AND COMMERCE

"Shooting a picture is holding your breath as all your faculties focus on capturing fleeting reality; then taking a picture becomes a moment of great physical and intellectual delight. It is a matter of putting your brain, your eye and your heart in the same line of sight. It is a way of life."

—Henri Cartier-Bresson[5]

Chapter 1

ART

All photographers have a "falling in love" tale to tell about how they came to image making. The ability to capture, interpret and share moments in time holds an undeniable power and, consequently, there is a steady flow of people drawn to this medium. This initial obsession frequently evolves into a desire to make this skill a vocation, but what does it really mean to be a photographer? What separates the hobbyist from the professional? The easy answer is that a professional is someone who generates income from photographic labors, but I feel that is too simplistic. I think Leslie Burns, marketing consultant to photographers, articulated it best when she stated clearly, "the difference is intent." True professionals have purpose behind the work they create; whether a photographer is fulfilling an assignment or producing art, the intention is guiding the work. The work is deliberate, the craft is honed, and the results are delivered. This work cycle is repeated with passion and persistence.

Throughout this book, I will share my own experiences and those of fellow photographers Richard Kelly and Sean Kernan. I invited Richard and Sean to participate in this project because our photography backgrounds and our clients are extremely varied, providing a depth of perspectives on the topics covered. We do share a steadfast commitment to photography as creative expression and an equally strong desire to continue our work as photographers. Each of us believes that the art of seeing is a way of life and we want that to thrive, both for ourselves and for others.

For me it started in a high school photography class. The thrill of seeing an image I created come up in the developer tray

grabbed me immediately and that passion has never waned. Art was my favorite school subject, but finding photography was a gift, an indefinable pull at an early age.

Richard Kelly discovered photography even earlier, after buying his first camera at thirteen. His parents made it clear from the start that they would not subsidize the film, paper, and chemistry he needed to keep making pictures. Consequently, at a much younger age than most, Richard needed to find a way to support his new habit and approached his hometown newspaper, *The News Tribune* in Beaver Falls, Pennsylvania. Too young to drive, Richard's mother was his means of transportation to and from these first photo assignments. From the start, Richard has rather seamlessly combined art and commerce by using his skills to generate income in support of his passion.

For Sean Kernan his introduction to photography came after college. After studying journalism and then working in a small theater company for three years, Sean decided to take a summer off to tour Europe. For this trip, based on the advice of friends, he purchased a camera to record his journey. Along the way, he discovered his camera was more than a tool for documenting scenery. Sean found that seeing and photography were becoming one creating, for him, a new way of communicating that was very different from the theater. Theater was constantly high production and hugely collaborative work, and although Sean enjoys that process, the camera provided him a "low production" way of expressing himself. He found this immensely satisfying and he was hooked for life.

We live in a world of images. Frankly, we are inundated with them. Turn on your computer, your television, your cell phone, walk down the street, ride a bus, or open a magazine and there is a constant flow of images before our eyes. Photography has, from its beginnings, been available to and used by both professionals and amateurs. Since the Kodak Brownie, anyone can create a photograph regardless of the operator's skill or understanding of how a camera works. Today, the speed of digital imagery combined with the ease of distribution made possible by the Internet has exploded the number of images out in the world.

Some photographs are used to sell a product or an idea, others are created for news reporting or event documentation and many more are simply being shared for the fun of it.

One result of this abundance is a more visually literate culture than was the case in previous generations. It is now readily acknowledged that imagery can both educate and manipulate. Photographs can evoke emotion, reveal a truth, and also lie. Furthermore, an image's importance is frequently not measured by any standards of craft or creativity, but rather by impact. Remember the images from Abu Ghraib prison in Iraq? The quality (or lack of quality) of these photographs has nothing to do with their continuing resonance. This occurs when the subject matter trumps artistic merit. Dramatic or horrifying subject matter, however, is not what makes up the typical everyday photograph. For professionals, the concern of this book, our role is more frequently to unveil what is special or unique in the flow of everyday events. Cameras literally record, making photography inherently tied to subject matter. The photographer brings a point of view to the process and, therefore, for the artist, subject matter is only the starting place.

Consider Lewis Hine's photographs documenting early twentieth century child labor. These images facilitated the introduction of child labor laws in the United States and have become an important record of this period of American history. The social impact of Hine's images is undisputed, but the subject matter is only one ingredient of the lasting value behind this work. Hine's masterful compositions draw the viewer's attention to precisely indicate his concerns. His portraits of children in these harsh work environments reveal an intimate connection between the subject and the photographer, as well as a deep, haunting sadness. Hine's vision pushes these images beyond photographic record making and speak to universal truths about the human condition.

Lauren Greenfield explores the social and personal life of American girls in her 2002 published book, *Girl Culture*. Greenfield expertly employs a raw journalistic style and produces images that are bold, honest, and intensely intimate. Again, we see an artist exposing harsh cultural realities, but through her vision and

tenacity the photographs move far beyond sociological study and become artful expression.

And now think about Aaron Siskind's photographs of ripped posters and graffiti. This series takes the subject matter out of context and transforms it into exquisite formal compositions. The strength of this vision then evolves further to express competing emotions of tension and tranquility. Siskind's subject, vision, and composition coalesce and bring lasting power to this work. Together these elements create something more than the sum of their parts.

Marilyn Bridges creates aerial photographs of ruins in Peru, Egypt, Greece, Britain, and the United States. Her image, *Arrows Over Rise, Nazca, Peru* is a breathtaking landscape photograph that not only describes the location but also transforms it. The composition draws you in by forcing a circular visual movement as you grasp the scale of the scene, and then the markings of an ancient culture are revealed jetting through the vertical center of the image. The quietest visual component, and subject of the image, suddenly takes on an undeniable power. Bridges elegantly describes her process: "By consciously maneuvering the aircraft in such a way as to place light and shadow in relationship to material forms, I control the shapes and patterns within the photograph. By maintaining the relationship between tone, shape and texture, the gesture evoked by the symbolic nature of the subject is reinforced. If all this works, then the photograph is alive and meaningful and not merely a record of the charted landscape." A well-seen photograph is, as it has always been, the most powerful communication tool available.

A photographer finds distinction in our visually saturated society through the pursuit of personal vision, refined through the practice of unwavering persistence. The art of seeing is perfected by the act of working. I had the privilege a few years back of hearing photographer Ken Josephson speak at the Society for Photographic Education Midwest Regional conference. While discussing his own struggle with blocks in creativity or direction, he clearly stated his own mantra, "work begets work." You must be dedicated to finding your own vision and, to do that, you must

make the photographs. There is no easy button to push in becoming an artist, and there is no one size fits all formula for success. It is personal and it is work.

The critical connection between an individual's vision and the lasting value of their work is expressed by photographer and writer Robert Adams: "Making photographs has to be, then, a personal matter; when it is not, the results are not persuasive. Only the artist's presence in the work can convince us that its affirmation resulted from and has been tested by human experience. Without the photographer in the photograph the view is no more compelling than the product of some anonymous record camera, a machine perhaps capable of happy accident but not of response to form."[6]

I remember the first time I recognized that my work could reveal more than the subject before me, in other words, the first time I realized I was an artist. I was staying with a friend in Chicago, as I often did prior to moving there, allowing myself days to photograph the city I was so enamored of. Brian was yelling down the hall of his apartment something about dinner and I was photographing candlesticks on his living room windowsill. The hot summer air was blowing in the window and the last light of the day was sculpting the candlesticks. I answered his question and simultaneously photographed the scene that had caught my eye. It was seamless and natural. I put the camera down and went to dinner. Weeks later in the darkroom, when I printed the image the entire event was replayed in my mind. The experience had been mundane yet the image staring back at me in the developing tray was somehow much more, I had successfully transcended the everyday event and had made the moment a personal expression. What part of myself had taken that picture? How could I repeat it? It was a powerful realization and has become the yardstick by which I measure the success of my work. It is a sort of calling, the creation of images that are more than mere description. The search for the next transcendent moment is what drives the artist in all of us to keep photographing.

A structured project is the vehicle most photographers use to achieve creative growth. We find our vision through the act of photographing, but we articulate our message through projects.

Every photographer has single monumental photographs, but a series of images revealing depths of an idea is the true lasting product of our labors.

Projects are discovered through the acts of working, seeing, and staying open to possibilities. Sean Kernan describes in his artist statement that his *Secret Books* project began when he was cleaning up his studio and simply picked up an old book and looked at it in a new way. "On an impulse, I went to the closet where I keep a compost heap of props and got four black Japanese river stones and set them out carefully in a line across the pages of the book. And suddenly it looked to me like . . . a poem . . . I took a picture of this poem. And that was the beginning of these books."

Sean clearly states the importance of this notion: "I've come to think that empty presence is the state an artist needs to be in when a great project hits. I'd suspected this for some time, that art begins in presence and is followed by thinking. My *Secret Books* project solidified that forever."

Similarly, the beginnings of my *Personal Spaces: Details of American Homes* project grew out of a non-photographic event: a family visit to my aunt's childhood home in Mississippi. Her mother, Mildred, had lived in this beautiful bungalow for decades and it percolated with personal history everywhere I looked. I walked around, took a few photographs, and left haunted with the notion that I had to find a way to get inside more homes like this. I was fixed on the idea that home interiors were my new subject matter, so I formalized the plan making forty years the marker for minimum occupancy and strategically reached out to family and friends for help. With no work to show, the owners of my first few home subjects opened up to me simply because of their trust in the family member or friend who had made the request on my behalf. Once I had work to show, the introductions were a little easier, but I still relied on the graciousness and trust of these homeowners, nearly all of whom I never met until the day I arrived to photograph the details of their lives. Beyond my own family and close friends, fellow photographers quickly became my biggest resource for new home material. This camaraderie of my col-

leagues not only made this project possible, it serves as a meaningful lesson in the value of photographers supporting each other.

Richard Kelly shares that working for Art Kane was his alternative graduate school. "Art was not a technical genius. He was a creative genius. He would give me drawings and say, 'Figure out how we can do this.' He gave me lots of freedom. I had my own office and access to any of his equipment. He paid for my film and processing. He encouraged me to shoot and test. We had a standing meeting every Monday morning to review my work. I had to produce new images every week for these critiques. Art was very direct and hands on, never letting me get away with not following through on an idea." Richard credits Art for teaching him both discipline and the importance of pursuing authentic projects.

Richard's *Artists and Scientists* project grew out of an assignment he was doing for the University of Pittsburgh. He photographed Dr. Manzi and Dr. Ahearn to document their research work on Lupus. "When I met these two scientists, I realized that being a scientist was like being an artist. The struggles were the same creative struggles photographers and artists go through. How does the eureka moment happen? I also discovered that many of these scientists were also painters and musicians. I have always created portraits of artists and now I expanded to scientists and this project was born." From cleaning up a studio to visiting family to completing a commercial assignment, the seeds of these significant projects came from unexpected places.

The process of developing a project does not always happen as a result of one event or realization. It can, and frequently does, take time and patience. An example of this is a body of work I call *Intimate Landscapes*. At the time I started this project, I was feeling completely vacant of a personal direction for my art. I was consumed with growing our small studio business and had not given my own work any substantial time or energy for quite a few years. My business partner, Gary Cialdella, gave me the path forward by suggesting I simply spend concentrated time photographing for myself. He kept reminding me not to worry about "what" I was photographing or "why"—that I should just photograph. I followed this advice and set aside a week at a time to walk

old Chicago neighborhoods and photograph. The work evolved and took root after extensive travel, photographing, printing, and editing. The series resonates with a blending of history, architecture, and the given moment. The resulting work is a series of poems, deeply personal and full of memory.

The key to the pursuit of art is to push yourself to freshly look at all of your images, identify your genuine interests and concerns and when the spark of a project idea hits, run with it. There is rarely a shortage of ideas, but there is a deficit in photographers willing to do the work of finding and executing projects true to themselves.

Chapter 2

COMMERCE

Creating a viable way to make a living from your art is a huge undertaking. Photographers often measure their business success against the commercial photography industry prior to the explosive use of the Internet and digital imagery. But what is frequently referred to as "the good old days" was really a very brief period during which the profession matured, the number of photographers was small, and the demand for our product was growing. Furthermore, it depends on who is speaking what period of time is actually being referenced. The picture magazine era of Eugene Smith is something I hear many photographers long for. They want those photo essay assignments for which you could spend weeks sinking your teeth into one project. Yet these photographers frequently worked for little money and had to fight for the rights to their work. Others are referring to the relatively stable and lucrative commercial photography era of the 1960s, '70s and '80s, when advertising budgets were on the rise and large format color transparencies were the standard. This period was not only short lived, but advertising agencies were (and still are) a difficult and fiercely competitive market to break into. Neither era guaranteed success or lasted for very long. This young industry is constantly evolving and to more fully understand the challenges that face us today it is useful to take a selected survey of our history as it relates to commerce and follow that with details on how Sean Kernan, Richard Kelly and I entered the field.

From Medieval guilds, to Renaissance academies, to church and state patrons, to modern academia and individual businesses, the creators of art have consistently survived by applying their talent to some sort of commercial endeavor. Ironically, "art for art's

sake" has been the prevailing mantra in university art departments over the past fifty years. My own art education shunned direct commercial use of art. The consensus, at the time, was that doing work for clients "hurt" your own work, polluting it somehow. The absurdity of this approach seems obvious to me today, some 25 years after graduating with my bachelor's degree. In the absence of other supporting income, one must make a living doing something. In addition, for artists to fully realize their goals they must make a living in a way that allows time, energy, and resources to create their personal work. Utilizing a specific craft to generate income not only perfects skills, but also yields freedoms of time and money necessary for the creative process to thrive. Being an artist and making a living from your craft do not have to be mutually exclusive; on the contrary, I believe they strengthen each other.

From the beginning, photography and commerce have been linked. Artists Nicéphore Niépce and Louis Daguerre, along with scientist William Fox Talbot, discovered photography. Working independently, they all used the camera obscura and camera lucida to preserve projected and reflected images onto permanent materials. Although the historical views of credit for this discovery vary, it is generally acknowledged that a still life image created by Daguerre in 1837 marks the beginning of the medium. Daguerre wrote and distributed a how-to manual for his discovery and simultaneously marketed the equipment needed to create a daguerreotype. By 1841, after a few technical improvements allowing for shorter exposure times, this process became an affordable way to create a photographic portrait and the business of portrait studios was born.[7]

Mathew Brady opened his portrait studio in New York City in 1844, quickly establishing the premier salon in the city. Brady's business expanded by employing other photographers, opening a studio in Washington DC and adapting to new photographic processes.[8] Brady refused to credit his employee photographers, which led to Alexander Gardner leaving his position with Brady's studio, taking Timothy O'Sullivan and others with him. Gardner and O'Sullivan continued the Civil War documentation they had

begun under Brady, launching their own reputations as photographers. By the second half of the nineteenth century, photographers were scouring the globe pursuing this new craft and meeting the growing public appetite for imagery of little known places. Many of these photographers established their own publishing companies and galleries to distribute and sell their work. Francis Frith, best known for images of the pyramids in Egypt, produced picture postcards as a successful business. Carleton Watkins and Eadweard Muybridge photographed the California landscape and marketed stereographs and prints through their competing galleries in San Francisco. Timothy O'Sullivan worked for various government surveys and expeditions. Edward Curtis, a Seattle portrait photographer, was able to undertake his meticulous documentation of the American Indians with the financial support of J.P. Morgan, American banker, financier, and art collector.

The Photographers Association of America, which later became the Professional Photographers of America (PPA) that we know today, was founded in 1880 signaling a growing profession. The young group's first conference included a demonstration of the new gelatin dry plate process.

During this same period, the struggle for photography to be accepted as an art form was brewing in the circles of the medium's more affluent practitioners. The "Pictorialists" used techniques to diffuse the clarity of a straight photograph combined with pastoral subject matter with the goal of emulating Impressionist paintings. Alfred Stieglitz was the leader of this movement in the United States, and created a society he named the Photo Secession. Stieglitz was supported by family money and took a negative view of individuals focusing on profit from their creative labors, but others in the group needed a vocation. Clarence H. White worked as an accountant in Ohio while building his reputation as an artist. He moved to New York in 1906, taught photography at Columbia University, and later opened his own photography school. After raising her children, Gertrude Kasebier owned and operated a portrait studio in New York City and sold her art prints. Her daughter eventually joined her in this successful business.[9]

The post-WWI era marks the beginning of commercial photography as we know it today. In *A New History of Photography*, Thomas Michael Gunther describes the birth of modern advertising as the transition, in the 1920's, from advertising that relied mostly on text to identify the unique characteristics of a product to the contemporary idea of publicity that uses images to articulate an idea. Selling tied to emotion rather than factual information became dominant and Gunther singles out the best way to send that message: ". . . photography proved to be the indispensable vehicle for the spread of ideas and lifestyles."[10] In 1917, the American Association of Advertising Agencies was founded, followed in 1920 by the creation of the Art Directors Club.

The precise and graphic still-life images of Paul Outerbridge, Jr. fit perfectly into this new growing commercial market. Outerbridge worked in New York City and opened an elaborate photography studio in Paris in 1922. Eduard Steichen was a partner with Stieglitz in their Gallery 291, served as a photographer for the US Army in WW1 and became an extremely successful fashion photographer for *Vogue* and *Vanity Fair*. From his sixties until his retirement, he served as the Director of the Department of Photography at the Museum of Modern Art. Imogen Cunningham assisted for Edward Curtis, opened a portrait studio in Seattle in 1910, and worked for *Vanity Fair* photographing politicians and Hollywood stars in the early 1930s. Cunningham received a Guggenheim fellowship in 1970.[11]

Berenice Abbott studied in Paris, assisted for Man Ray and opened her own portrait studio there in 1926. She returned to New York taking assignments from *Fortune* magazine, championed the work of Eugene Atget that she had acquired in Paris, and documented the city with support from the Federal Art Project of the Works Progress Administration. In 1941, Abbott published the instructional manual, "A Guide to Better Photography,"[12] Walker Evans left his office job in 1930 to pursue a career as a photographer. That year Hart Crane published his poem "The Bridge" using Evans' photographs as illustrations. Some of these Brooklyn Bridge images were also published in magazines and Evans enjoyed a decent period of commissioned work, including a large job documenting

African sculpture for the Museum of Modern Art. In 1935, Evans joined Roy Stryker's staff at the Division of Information, later re-named the Farm Security Administration, which was charged with photographing activities of the Resettlement Administration.[13]

The forties saw the blossoming of *Look* and *Life* picture magazines. The popular "photo essays" of this era built the careers of many professional photographers. The American Society of Magazine Photographers (now The American Society of Media Photographers) was founded in 1944 by leading photojournalists of the day in response to unfavorable working conditions with these publications. Photographers banned together to work for attribution, fair compensation, and the ability to maintain the rights to their work. Magnum, a photographic co-operative, was established in 1947 by photojournalists Robert Capa, Henri Cartier-Bresson, David Seymour, and George Rodger. Capa's vision for this agency was born out of his desire for steady work, maintaining his copyrights, and the ability to pursue assignments based on his interests. Russell Miller, in his biography of the agency, explains the birth of Magnum: "Each of them would contribute $400 to cover initial expenses and the new agency would extract 40 percent of the fees from assignments it set up for its photographer-members, 30 percent of the fees from assignments the photographers arranged for themselves and 50 percent of reprint fees."[14] This photographer-owned agency is now over sixty years old with editorial offices in New York, London, Paris, and Tokyo. Current members include Eliott Erwitt, Eve Arnold, and Steve McCurry.

Richard Avedon started his career as a photographer for a department store and by 1946 opened his own studio doing fashion work for *Harper's Bazaar* and *Vogue*. His illustrious career includes portrait and fashion work for advertising and editorial clients, as well as pursuing his personal projects distributed through exhibitions and publications. Arnold Newman started his career working for a portrait studio in Philadelphia and opened his own studio in West Palm Beach before relocating to New York in 1945. In New York, he launched his career as the father of the environmental portrait taking assignments for *Fortune*, *Life*, *Newsweek*, the *New Yorker*, and *Esquire*.

The very visible success of these photographers and others led to an increase in photographers entering the field. The use of photographs grew and so did the profession. Rochester Institute of Technology established its photography department in 1930 and Brooks Institute of Photography was founded in 1945. Throughout the 1960s and '70s, many universities set up photography programs within their fine art and journalism departments.

A natural outgrowth of all this expansion is a still-dominant industry fractionalization: more photography uses created areas of specialization and photographers began focusing on one area to the exclusion of another. This can have some practical benefits for practitioners by refining skills for one purpose, but unfortunately, in terms of our individual artistic and business need for flexibility, these camps are frequently more negative than positive. We have journalism vs. advertising vs. fine art vs. portrait vs. wedding vs. stock vs. teaching vs. video and the list goes on. Particular business norms entrenched in each photography genre can affect structure, pricing, licensing, lifestyle, and prestige, and while knowledge of the norms are necessary when working in a given area, the successful contemporary photographer needs the ability to work in and for multiple outlets. In recent years, with fast paced technology changes and the ease of electronic distribution, we have seen a breakdown in the walls between these photography genres and, thankfully, the bias frequently attached to working one-way versus another has also decreased.

Sean Kernan started his career as the big picture magazine era was winding down. He studied journalism at the University of Pennsylvania believing he would pursue that field, but upon graduation he had no real plan or desire to make that a reality. He had participated in theater at college and found work apprenticing for a small theater in New Haven called the Long Wharf. He moved from apprentice to being part of the company to becoming the Production Stage Manager.

Sean was ready for a change and left this job to travel Europe. He took a camera along as tourists frequently do and unexpectedly discovered his affinity for creating photographs. Sean returned to the states, settled in New York City and continued to pursue his

new photography passion. Drawing on his past experience, he did his first professional photography work documenting theater productions.

His editorial and theater clients gave him assignments he enjoyed, but the pay scale was low. Around this time, an art director called after seeing Sean's work. Sean acknowledges that this kind of thing hardly ever happens today, but in the early seventies professional photographers were still relatively rare making the task of getting noticed much easier. In this case, this art director hired Sean to take a portrait of the owners of a rug shop and the agency paid him $500. Sean was empowered. This was good money and if he could do this type of work regularly, he could support himself and the production of his own photography. This marks the beginning for Sean envisioning his career as a professional photographer. He soon discovered that keeping the assignments rolling in on a regular basis was not so easy, but gradually he grew a successful business and an impressive client list that includes: AT&T, Harvard University, Microsoft, *New York Times Magazine*, and Tropicana.

Sean moved his studio from New York City to Stony Creek, Connecticut in 1980. While on a bike ride with his future wife, Sean was drawn to a 1750 farmhouse and within a week he purchased it. His studio is in an old school house and provides him space for client and personal work. Sean has continually pursued and exhibited his own photography and is the author of two monographs, The *Secret Books* with Jorge Luis Borges, and *Among Trees*. He also teaches and lectures with his primary focus on exploring the · nature of creativity and its central role in our lives.

Richard Kelly used the mentor system to develop his skills, business acumen and vision. After those early days with a camera working on assignments for his local paper, Richard had a supportive high school art teacher and worked at the local camera store where he met the professionals in the community. He was able to go on industrial assignments and even attended meetings of the Photographers of Industry, a regional association of professionals. Richard met and was influenced by Duane Michals and Dean Collins. He began seeing photography at a higher level, pushing

himself to improve his craft and attending college to study photography. Due to family finances Richard had to leave the Rochester Institute of Technology after one year.

With no good job prospects in Pennsylvania, in 1985 he followed his family when they relocated to Ft. Lauderdale, Florida. Richard immediately got a job at a local camera store and, on weekends for no pay, he assisted the professionals he met at the store. Fashion photographer David Vance judged an assistants' show Richard entered and offered him a job as a black and white printer. Richard describes this step in his career: "I thought I was a good printer until I worked for David—he turned me into a good printer. He taught me how an assistant should act, how to organize and produce a photo shoot. I knew nothing about fashion and beauty photography when I started with him. He said to me right away, 'You are going to have to go to New York, we are going to prepare you for that,' and that is what he did." David encouraged and paid for Richard to attend Art Kane's Maine Workshop "The Conceptual Portrait." By the time he returned to Florida, he was making plans to move to New York City. After assisting for a few months in New York City, Richard was hired by Art Kane as his first assistant doing everything from working out a photography lighting challenge to picking up his laundry.

As Art Kane's career was winding down, Richard wasn't needed full time and he started assisting and producing for other photographers, as well as shooting some of his own magazine assignments. Richard traveled extensively with Kurt Markus, as his first assistant and eventually as a producer, and was offered a full time job contingent on relocating to Montana. Richard made the decision to strike out on his own and stayed in New York. His interest was in editorial work, but the work was scarce as magazines, not for the first or last time, were scaling back.

For a few years, Richard shuttled between Pittsburgh and New York. "I really do not know what I was thinking in moving back to Pittsburgh. It drew me back, but it wasn't a very viable market. It was an old boys network and hard to get appointments and assignments. I was still going back to New York for assignments. For three years, I had my feet in both places. That doesn't work. I had

no brand, no one knew who I was, I had two addresses, two phone numbers and a pager. It was confusing." The core clients Richard developed during this transition to Pittsburgh, the television show *Mr. Rogers' Neighborhood, Pittsburgh Magazine*, and the University of Pittsburgh, became the foundation of his new business.

Richard took a few years off from his own business taking a job at WQED, publisher of *Pittsburgh Magazine*, as their director of photography. This salaried position gave Richard a desirable steady income as he started a family, gave him the time to develop his skills in digital photography, and the job raised his profile in the Pittsburgh community. In 2007, Richard left and once again entered the freelance world. "I emerged from QED with a higher status in the community, which led to higher paying jobs for capital campaigns and annual reports."

Richard exhibits his work regularly and in 2009 received a fellowship from the Pennsylvania Council for the Arts for his project "Artists and Scientists" which is featured in this book. Richard supports his belief in the mentor process by consistently working with interns in his business and as an adjunct instructor at the Pittsburgh Filmmakers. In 2007, he was elected to the American Society of Media Photographers national board and became the society's president two years later where, in this role, he champions the need for copyright education and new business models for photographers.

After being introduced to photography in high school, I studied art in college and received a bachelor of arts with an emphasis in photography. I took my first photo-related job a few months after graduating as a black and white printer for a commercial photographer. After a couple of years, I left this job to start my own black and white lab business. I bartered with my friend and fellow photographer, Gary Cialdella, for darkroom space. Gary was in graduate school at the time and needed an assistant to process and print his work. I did this in exchange for the use of his basement darkroom to run my small photo lab business. This business gave me a base income to build upon. I started to take photographs for a local business magazine. This was my first steady photography account, providing three to six editorial stories per

month. Gary and I decided to combine our few shooting accounts and form a partnership. We officially started our business in 1987 and a year later, we moved out of Gary's basement into a small loft studio space in a 1903 firehouse. I continued to run my lab business while working with Gary on marketing our new joint studio venture.

The local business magazine account grew, we became their primary photographers, and part of our compensation was advertising in the magazine. A regional construction firm contacted us based on one of those ads. They were looking for a photographer to document their numerous projects. This account launched our career as architectural photographers. We worked alone on these projects and learned through trial and error how to intricately light interior spaces. This was our training place for quality architectural imagery that became a marker of our business. We also pursued generalist work doing product illustration, still-life imagery, business portraits, and manufacturing and lifestyle photography. While always pursuing architecture as a specialty, we maintained this generalist studio in Kalamazoo, Michigan, until 2005.

When our last studio product account left, the advertising agency lost the account and consequently we did, too. We both knew it was time to leave our studio space. Without the product photography accounts it was not possible to maintain our studio's overhead. For some time our business marketing was focused on architectural work and the need for dramatic change was evident. The manufacturing base of Michigan's economy had been steadily dropping off for years. The small machine shops scattered throughout southwest Michigan that supplied the auto industry in Detroit were closing on a regular basis. Pfizer now owned the Upjohn Company, Kalamazoo's largest employer, and all marketing jobs had been moved out of our town. The ripple effect of all this change was felt throughout the creative community, advertising agencies, public relation firms, graphic designers, printers, and photographers. There simply was not enough advertising and marketing work in our area to support its numerous photography studios.

In late 2004, I made the difficult decision that I would move to Chicago, and we left our studio space of seventeen years. Gary and I remained business partners, but he stayed in Kalamazoo with his family. Our business address was now in Chicago and we began focusing our efforts on the architectural photography market in my new home. This larger and economically diverse metropolitan area provided our business with new opportunities.

After a few successful years in Chicago and a stabilizing profit margin, the 2009 economic disaster hit. The building industry was paralyzed and soon our old and new architectural client work slowed to a trickle. We found ourselves, once again, needing to reinvent our business. While the new clients had renewed our faith in making a living in the traditional architectural photography market, we had known for a while that our hearts were no longer in that work. This economic downturn provided an opportunity for us to take a leap of faith and restructure our business, this time toward a dream we have carried for some time. Our energies this past year have been focused on building a business combining our personal photography, writing, and teaching skills pursuing our love for the medium through its practice and as educators. We plan to produce and market our own documentary photography, as well as offer consultations and workshops to photographers. Our goal is to promote photography as a true resource with lasting personal and cultural value.

Sean, Richard, and I share a real pride in our commercial work. While we each pursue our own personal photography, we relish satisfying a paying customer. Pursuing photography professionally is hard work requiring a myriad of creative, technical, and business skills. Many photographers coming before us have used their talents to support themselves and their own work; their varied career trajectories and resulting images are inspirational. By studying the history of our profession, you can strengthen your determination to uncover a distinct and genuine career path.

Chapter 3

ARRIVING AT A PEACEFUL COALESCENCE

The demands of running a small creative business in a commoditized economy are vast. We need profitability, yet a balance of market forces and personal creative sensibilities is often difficult to achieve. At what point does the creative process give way to the more practical matters of running a business? And is it possible for the two to coexist or are they preordained to be at constant odds with one another? The Internet has fostered an explosion of choice and also mediocrity. There is a clear need for quality. The conditions are ripe for photographers to fill this vacuum with distinctive and genuine photography. The path to follow, I believe, is for photographers to clearly define their personal vision, produce work committed to that vision and, in turn, to identify appropriate commercial uses for their skills.

Separate Art and Business

Commissioned work is made for the paying customer. We put our mark on that work as much as possible, but the absolute goal of these photographs is satisfying the needs of the client. Even when hired for your unique style, the application of that look is to serve a commercial intent. Whether making images to illustrate a magazine article or a company Web site, to document an event, or to create an image for an advertisement, the work produced must serve the needs of the specific use of the customer. Personal projects, on the other hand, germinate from our passions and interests. Understanding this separation is step one to empowering both your art and business worlds.

We have all had the experience of a client not using what we believe to be the best selection from a shoot, or have found our work objectionably cropped in print. The dissatisfaction of not finding fulfillment in my commercial work was a frequent early business struggle. The resolution came only when I accepted my commissioned assignments as challenges to fulfill the needs of our clients rather than an outlet for my own expression. The clean separation was freeing and I believe our clients receive more value when my priorities are properly placed entirely on them.

Conversely, my desire for personal expression is only achieved through the pursuit of projects focused entirely on my own interests. Two years ago, I started a new project photographing where I live, the Chicago neighborhood of Rogers Park. Last summer, I felt I was not dedicating the time necessary to establish a direction for this work. As I have successfully done in the past, I knew that establishing a structure would help me find a resolution and I set out on a one-day assignment. Last Labor Day, I walked and photographed the parameter of the neighborhood covering about eight miles in six hours. The film (yes, still film for much of my personal work) shot that day resulted in over seventy-five work prints that I used to critique and formulate the next phase of this project. For me, the exhilaration of doing this work is the most satisfying part of the photographic process. It is not possible to ask this of client assignments; this level of fulfillment only comes from pursuing the work that comes from within.

I am fortunate to have a business partner sharing the burdens and successes of running a small studio. Gary and I founded our business on the belief that we need to nurture our individual creative work. This shared commitment has guided financial decisions that are frequently at odds with traditional "it's best for business" solutions. Compromises are inevitable, times when plans must give way to a client's deadline or a desired piece of equipment is not affordable, but having a mutual understanding that each person's creative growth is central to the partnership has worked more often than not. One of us will cover for the other if a personal photography trip is scheduled making sure the necessary time is allotted for our own work. We seek out continued education

opportunities that enrich creativity, as well as technique and business skills.

New York Times Magazine recently hired Sean to photograph John Irvine. The young photo editor was attracted to Sean's personal series of manipulated black and white collage portraits. He wanted this style for the commissioned Irvine portrait. In the end, the magazine used one of the single frame images Sean had done. While Sean might have preferred his more unique style be used, in the end it really did not matter—the client was thrilled and that is the mark of a successful commercial transaction. The separation Sean faithfully keeps between what is for the client and what is for himself allows him to maintain this healthy perspective.

Richard delights in the communication challenge of client work—he solves their problems visually. "I get a high from that. I love seeing my work in use. I love collaborating with talented designers who take what I do and add value to it." While that satisfaction is real, it isn't enough. Richard pursues his own projects and feels they are "the engine that keeps everything else in my life moving."

Refine Your Personal Vision

We cannot find distinction without actually being distinct. While this transparent solution sounds simple, the path and the heavy lifting are up to the individual.

In his commercial assignments, Sean is frequently involved in large production shoots with sets and lots of people. "These projects make me anxious, but I like them. The client projects give me something to focus on. It is easier than the ephemeral." The unknown is what Sean finds the most interesting and he pushes himself to always return to his own work. "I have to treat the creative endeavor as a crucial part of my job. So I schedule it just like any other part of my job—I put personal shooting on the calendar and respect it." For Sean, his personal work usually involves travel that requires blocks of time. The freedom to set this time aside is, for him, the best part of being an independent

photographer. If utilized properly, the freedom this lifestyle offers can yield the time needed for true growth as an artist.

Time management is often the largest stumbling block for our own work. Unlike Sean, Richard needs to break his personal work time into smaller pieces. Furthermore, he schedules his own shooting for mornings in the first half of the week finding that any given day can be consumed with business or family demands. By acknowledging the limits on his time and planning appropriately, the work gets done.

Richard got his first Diana, an inexpensive plastic rangefinder camera, in 1985. After years of working to make his images precise, the simplicity of photographing with this one setting, one lens camera was freeing. The results were more random, breaking all the rules Richard previously embraced, and the work led to new discoveries that enhanced his vision. Today, the iPhone is Richard's new Diana camera. The spontaneity of capturing images, once again, on the fly has produced new ideas and themes in his work. The ease of sharing these iPhone photos via Facebook has added another component to this growth. "I realize how much my community matters. The feedback can fuel the work." Richard admits he has pulled back a bit on this online posting, reserving images for himself and other future uses. "It is all a balance—the responses inspire me, yet I also need to not over share. Sometimes, I need to think about the work uninfluenced by the opinion of others."

The act of seeing is improved the more we photograph and photographing without a plan is something Sean believes we should embrace. "My first photos were done just walking around with nothing in mind, and the result transformed me. That's how important that was."

As discussed in chapter 1, however, the most commonly adopted method for lasting artistic growth is the personal project. A project is established when we define an interest, set param-eters to give that subject or idea structure and then produce the work. Projects give us the framework for true artistic discovery and the product is the most attractive form for presentation,

publishing, and exhibition. Utilizing new methods, such as multi-media and video, give our projects a new life especially in the world of online publishing.

When I started my "Personal Spaces" project I thought the idea would allow me to photograph historic and significant residential architecture. While I did encounter some of these opportunities, it became evident quickly that houses were not the subjects. The objects in the homes and by extension the people are the soul of this project. The bulk of this portfolio is best described as still-lifes, not interiors, and that is very different than I originally planned. The importance of staying open to change during the evolution of a project is crucial. We need the parameters—for me I used one camera, one lens, available light, and the occupant had to have resided in the home for a minimum of forty years. I gave myself no other restrictions. What I photographed once I was in a given home was never defined. That freedom within limits let me discover what this project was really about.

Sean states that working on projects gives him a process to expand his thinking. "The power accumulates and gets me to images that I couldn't set out to take. When that happens, I know I'm getting somewhere."

Combine Art and Business

Successfully incorporating art into the business world isn't easy and it takes courage. Once you have created genuine personal work the next step is sharing it, and receiving accolades is never guaranteed. This process, as Robert Adams shares, can be quite humbling. "Almost all photographers have incurred large expenses in the pursuit of tiny audiences, finding that the wonder they'd hoped to share is something few want to receive. Nothing is so clarifying, for instance, as to stand through the opening of an exhibition to which only officials have come."[15] I was told by a photographer that he will not attend any workshops after one instructor critically critiqued his work and by another that she refuses to enter any juried exhibitions after being rejected a few times. We all have these types of protectionist responses, but we

must not allow ourselves to be paralyzed by individual reactions. Responses to art are subjective and we need to resist the urge to give any one reaction too much power over our work or our futures. It is not a given that winning an award will yield a successful career any more than a single critical review can destroy one.

Showing a potential customer work you have completed for a paying client is sometimes necessary, particularly when you are starting out, to instill confidence by proving that "yes, people do hire me." Make sure, however, that client work is not all you show, as it is frequently the images created solely from your heart that will sell your services best. The more you can blend these two parts of your imagery in style and presentations the better.

The traditional portfolio approach for all three of us, as well as many other photographers, is separating our work into categories. This is particularly apparent on our Web sites, partitioning the client work from the personal. Sean does this, but he places the personal at the forefront. "I lead my marketing with my personal stuff because it shows how I see. Then I follow with commercial work that shows how I can execute and bring off a group idea." Richard structures his presentation around themes and projects. "I usually tag personal projects distinct from commercial projects. There are occasions where I mix them together perhaps in a similar fashion that a curator might organize a retrospective. Juxtaposing one subject to another."

This idea of mixing our work in presentations is one I recently started using in face-to-face sales calls. I show a carefully se-quenced portfolio of images pulled from all types of work. The visual flow I orchestrate seems to take the question of why the work was produced off the table; my prospects focus more exclu-sively on the photography. I have found it to be a very effective way to communicate the uniqueness of our vision and by exten-sion, our business. As I write this, we are currently designing a new Web site that incorporates this approach.

As photographers, we are unique in that our chosen art form is actually something the business and consumer markets need and use regularly. Photographs have a seemingly endless list of uses:

wedding albums, advertising, product packaging, personal Web sites, business Web sites, consumer Web sites, Facebook profiles, news reporting, billboards, fine art display, how-to manuals, historic documentation, blogs, t-shirts, coffee mugs, screen savers, scrapbooks, book reports, encyclopedias, text books, magazines, refrigerator magnets, annual reports, postcards, greeting cards, and the list continues. Other arts are not so commercially applicable, as Sean points out. "There is a whole world of poetry out there, but no one makes any money at it."

The extensive use of photographs presents opportunity by providing us a way to make a living with our craft. It also presents a challenge as we can be consumed by our commissioned endeavors, putting our desire for personal expression at risk. The juggling of our two worlds, art and business, will be a constant in our careers. And it is important to remember, as noted above, even without a clear path for a poet to make a living from her creations, poetry continues to be written everyday. When passion and profession collide, passion will continue with or without financial rewards. As professionals, we have to provide a product that clients will pay us to create, and not every photographic use has that potential, a challenge that I will discuss in depth in the next chapter.

Sean discusses the ongoing struggle of the professional photographer: "The more time you give to sussing out people's needs and arriving at a solution, the more time you are taking away from leaping to the unexpected. The more you leap to the unexpected, the more you can bring back to the commercial work. So they feed each other, but they pull on each other and sometimes undercut each other. All the good stuff, in my personal work, happens when things fall apart. My commercial work depends on things not falling apart."

Clients compensate us to provide risk-free results, yet we grow as artists when we loosen control and leave more to happenstance. Again, this is why executing your own projects is imperative to your development both as a businessperson and as an artist. The ambiguous nature of making art nurtures our creativity and improves the more controlled aesthetic offerings of our commissioned

assignments. The discipline of working commercially hones craft and sharpens problem-solving skills, which, in turn, enhances the work you create for yourself. Once arriving at this state of productive harmony, professional photographers can realize their full potential in art and business.

A REALISTIC LOOK AT THE INDUSTRY

"Everything is free now, that's what they say. Everything I ever done, gotta give it away. Someone hit the big score, they figured it out, that we're gonna do it any-way, even if it doesn't pay."

—Gillian Welch

Chapter 4

WHERE ARE THE CLIENTS?

When Gillian Welch released the song "Everything is Free" in 2001 the lyrics rang very true to me. My heart sank with the thought that maintaining a viable income from my photography was becoming less and less possible, but the cutting truth spoken in her words, "they figured it out, that we're gonna to do it anyway, even if it doesn't pay," was the most painful part. It is thrilling to create something and to have the passion to create as your driving force is even more amazing, but for those of us who want a career creating images, some kind of income is critical to the equation. The money and time to do the work has to come from somewhere. So who are the clients in this new economy?

First let's put this conversation in perspective by looking at the recent history of the professional photography industry. For those of you who are new to this field, it is necessary to understand our not so distant past to appropriately navigate the current landscape. If you have worked in this industry for a while, a clearer understanding of the last two decades will hopefully help you accept and adapt to the changed business landscape. I hear many photographers say, "What happened here? Where did the clients go?" Well, a sort of perfect storm is what happened and things are still shaking out. The impact of the World Wide Web and technologies developed to use it cannot be emphasized enough. The ease and low cost of distributing information that the Internet provides has affected every industry, and photography is no exception.

The expansion of stock photography businesses, which license existing art for much less than the cost to produce custom work, hit every assignment photographer hard. Corbis Corporation was

founded in 1989 and Getty Images in 1995. Both companies actively bought up many small stock agencies and image collections consolidating the stock photography business and driving prices downward in the process. By 1996, I no longer produced any images for clients unless they were people, product or place specific. From this time forward, if the client's needs are generic, they purchase the much less expensive commodity option that stock photography offers. In addition to the explosion of cheap available stock photographs, the era of corporate consolidations worldwide was having an effect. Fewer companies meant fewer marketing departments and fewer advertisers. Simultaneously with all this, the industry moved from film to digital imaging and photographers had to face a huge technology hurdle. The transition is now complete and the industry standard is digital image delivery, but the cost to our distinctiveness as professionals is high and the list of collateral damage is long. Gone is the need to gel lights for color accuracy, in some cases gone is the need to even use a supplemental light at all, gone is the need to get the exposure perfect on set, gone is the need to avoid retouching by carefully orchestrating all elements of the photograph, gone is the business of making prints for clients, gone is the high financial bar to enter the field, and the list goes on. Many of the services we relied on to sell our clients on the cost of professional photography are no longer services they want or need. While cheap stock photography, business consolidation, and the digital revolution had many assignment photographers struggling to maintain good profit margins, the real game changer was rolling down the tracks and most of us had no idea it was coming.

While attending Photo Plus Expo 2004 in New York City, I had the good fortune of attending a lecture by marketing expert Seth Godin. His topic was his newly published book *Free Prize Inside*. Godin's presentation illustrated the new explosion of consumer choice through images of his local grocery store—a view of the cheese counter graphically communicated how difficult it is for a product to stand out in our new world of many options. In *Free Prize Inside*, Godin describes clearly how traditional marketing and advertising no longer works. "There are plenty of products that

used to be right there in the middle of our radar screen." This is the world I grew up in, where decent products wrapped in nicely designed packaging were promoted to us in carefully crafted and clever advertising. Most of us can still sing jingles from this era (plop, plop, fizz, fizz . . .) and still use brand names to describe products (Kleenex when we mean tissue). There was nothing extraordinarily special about these products, we purchased these products because given minimal options we picked the one that had name recognition. The advertising these businesses engaged in built brand name identity and purchasing these products felt like the safe, even the best choice. Godin continues, "Every time the brand marketers spent $100 on advertising and other forms of interruption, they made $200 in profit. . . . They were able to charge non-commodity prices because they'd created a brand. Today, twenty years later, it's easy for a marketer to get nostalgic about this. One product after another is fading away, for a simple reason: The ads can't pay for themselves anymore . . . In an era of too much noise and too much clutter and too many choices and too many channels and too much spam, you can't make a good living by interrupting people over and over."[16]

A light bulb went off for me. The downward pressure on my pricing and requests for all rights to my images was not being primarily driven by stock photography or the shift to digital imaging over film as I frequently complained, but rather by the simple fact that the old ways of marketing that my clients relied on to increase their profits were no longer working. The investments they were making in photography, graphic design, advertising agencies, printing, and paid media space were now an expense that had no guaranteed return. The economic model I built my entire business on was falling apart.

When advertising campaigns could virtually promise a certain return on each dollar invested, photographers had the leverage to license per use. Run another ad, the client is going to make more money, and the photographer, whose work is illustrating the ad, gets a piece of that pie. Advertising agencies could sell this practical approach to clients because everyone in the chain of production was making a profit. When the consistency of the

returns on advertising investments started to waver, the old way of licensing photography was drawn into question.

I have a vague memory of Amazon's decision to stop advertising and offer free shipping instead, but I had no idea that the result would impact my business beyond the obvious selfish benefit of buying books cheaper and getting free delivery. Godin describes what happened,

> *A year ago, Amazon.com announced that they were going to stop advertising altogether. No more TV. No more magazine ads. Instead, the company decided to put the money it was spending on ads into free shipping instead. Marketers were aghast. The idea of investing your ad dollars into actually making the product better was heresy. Pundits once again proclaimed the death of Amazon. After twelve months, the results were in. Sales for the year were up 37 percent. International growth was an astonishing 81 percent.*[17]

Amazon made this move in 2003. They strategically stopped using the traditional system of advertising and decided to put those resources towards making their service better and other businesses soon followed. Think about your clients—while their reduction in marketing dollars may be more reactionary than strategic, they likely have and continue to steadily reduce their budgets on things like professional photography. The ripple effect on small and large businesses is huge. Remember this the next time you pass an unused billboard, look at the lack of extravagance in a current annual report, notice the shrinking size of your favorite magazine, or the demise of your local newspaper, printer, or ad agency. The evidence is everywhere telling us that we have to throw out all we thought to be true about how to make money as a creative producer because the users of our "product" have changed how they communicate to their customers. And, to further complicate things, the number of people using non-professional photography to sell something explodes, like eBay and Craigslist. The growth of personal choice made possible by the new ease of information distribution via the Internet is crashing down on both our traditional clients and us. Average products in slick packaging no longer work for anyone. There are simply too

many readily available choices. If something isn't exactly what you want, whether it is the music you listen to, the shampoo you buy, where you grocery shop, or the photographer you hire, there are many other options at your fingertips.

Chris Anderson, editor in chief of *Wired* magazine, published *The Long Tail* in 2006 and defined how technology was changing the way business is done.

> *The theory of the Long Tail can be boiled down to this: Our culture and economy are increasingly shifting away from a focus on a relatively small number of hits (mainstream products and markets) at the head of the demand curve, and moving toward a huge number of niches in the tail. In an era without the constraints of physical shelf space and other bottlenecks of distribution, narrowly targeted goods and services can be as economically attractive as mainstream fare.*[18]

The irony of the long tail Anderson defines is that this phenomenon both undercuts the traditional markets for professional photography and presents photographers with more affordable ways to reach new clients and markets. The *New York Times* on March 29, 2010 reported that ad pages in magazines declined by 41 percent from 2001 to 2009 and in 2009 alone, 428 magazines closed.[19] This advertising demise hurt printed magazines, so they cut down on editorial content to save costs. That translates to lower budgets and fewer photographers being hired to cover stories. Classified ads are no longer a large profit center for newspapers and paid subscriptions are diminished by free online access and many other news options, so staff photojournalists are losing jobs in droves. Advertising agencies no longer generate high profits from commissions on securing paid media advertising space and are pressured to account for every penny spent on services like photography. The big budget campaigns of recent decades are gone.

On the flip side, photographers no longer need to pay for expensive source book ads to get their work in front of clients. Direct mail is expensive, but e-mail promotions are not. Web sites can be updated and tailored for specific markets with ease and little

expense. Social media sites can be used to build a brand and find new contacts. It takes time, energy, and persistence, but it doesn't take a large financial investment. The photographer who previously was held back by a lack of resources can now find marketing opportunities like never before. The ease and low cost of publishing online, however, democratizes the showcasing of images. These new tools are readily available to all, not just the professional.

The professional photographer has always battled the fact that their chosen vocation is an avocation for many others. In 1946, Chris Abel articulated this in his book *Professional Photography for Profit*,

> *Are you sold on photography? It would not be necessary to ask this question or to devote a full chapter to its discussion were it not for the mistaken impression held by many people that photography is a very easy method of making a living. This misapprehension is fostered by the simplicity with which almost anyone who owns a box camera can occasionally produce a good landscape or interior, or even an excellent portrait likeness . . . it is important for you to bear in mind that your competitors will not only be your brother photographers in your own and nearby communities, but the amateurs as well.*[20]

The presence of the amateur in the professional marketplace is not new, but an increased amateur access to our clients is. In 2008, Getty Images (licensor of photography) and Flickr (photo sharing community) signed an exclusive partnership. This collaboration directly and deliberately connects the photo enthusiasts with commercial buyers by establishing a Flickr-branded collection in the online image-licensing machine of Getty Images.[21] A smart move for both businesses offering buyers more choice and offering a little "extra" cash to the hobbyist who originally created the images with no monetary objective. In a little over a year, this stock photography offering contains 100,000 images. Based on the success of this vetted Flickr collection on Getty Images, the two companies are expanding their business venture with "Request to License," an option for all members of Flickr. Any Flickr participant can mark their images as available

to license, if a potential customer clicks on the licensing link, they are connected with a Getty sales representative who in turn contacts the photographer with details on the potential sale. These new Flickr features mean this Yahoo owned sharing service is now clearly participating in the commerce side of photography. The blurring of the line between the amateur and the professional continues signaling the need to drop preconceived notions of what we do and who we do business with.

Chris Anderson's controversial book *Free* created quite a buzz in the professional photographic community when it was released in 2009. The gut reaction by many photographers was negative surmising that Anderson was pitting free against paid to the detriment of the professional in any field. Anderson actually does a masterful job of outlining a history of how businesses have used the "free economy" to build products and services people will pay for. Anderson writes, "The way to compete with Free is to move past the abundance to find the adjacent scarcity. If software is free, sell support. If phone calls are free, sell distant labor and talent that can be reached by those free calls (the Indian outsourcing model in a nutshell). If your skills are being turned into a commodity that can be done by software (hello, travel agents, stockbrokers, and realtors), then move upstream to more complicated problems that still require the human touch. Not only can you compete with Free in that instance, but the people who need these custom solutions are often the ones most willing to pay highly for them."[22]

Like it or not, the photographs licensed every day and, in many cases, even the service of photography are now commodities. Generic photographic subject matter will no longer produce substantial financial rewards nor will it be possible to build a career taking corporate headshots. I return to Godin who always seems to concisely hit the nail on the head. "Your organization is based on exploiting scarcity. Create and sell something scarce and you can earn a profit. But when scarce things become common, and common things become scarce, you need to alter what you do all day."[23] Godin further offers that spare time, trust, and attention are things that used to be abundant and are now scarce. Remember these when formulating your business strategy; potential

clients do not have extra time, have trouble giving things attention, and are skeptical as a default. Turn those challenges into assets by saving clients time, being easy to do business with and building trust through quality and professionalism.

Photographs in general are definitely not scarce. We cannot compete on price when seemingly endless images are available for free or nearly free. We cannot compete with mediocre imagery when there are loads of one-click options for obtaining mediocre photographs. Photographers must define what they can bring to the table that is rare and that brings us back to creativity. A specific vision, style, or point of view directed towards a particular passion or interest is our one true unique offering. As a photographer, you need to develop a vision in your imagery, but that same creative thinking needs to be applied to how you run your business. Make it a package, so that all components speak to the same core message of genuine quality and value.

Marketing and creative consultant Leslie Burns defines the critical first step for photographers to implement effective marketing, "You need to be able to frame your business, your story concisely and in a way that will get others interested. That, in a nutshell, is effective marketing: telling your story to the right people in a way that will interest and excite them so that they want to become part of your story." This is no small task, but it is critical if your goal is a sustainable photography career. Burns coined the name "Vision Marketing Statement (VMS)" to describe the product of this process and I think it the perfect phrase for these times. She focuses photographers on identifying their most unique asset and in turn gives them the proper framework to build a marketing plan.

It is your vision, your way of seeing that really differentiates your business from every other photographer's business, and it is the most important factor in appealing to clients. Every other factor comes in far below your vision, your individual creativity and abilities, when it comes to getting the good clients and the great projects . . . Besides, if you can be the

only photographer who shoots a certain way, you can charge a much higher Creative Fee. That's simple supply and demand.[24]

Once you clarify your uniqueness, you need to define your target audience, but consider the changes discussed here and think differently. If you are interested in editorial work, consider becoming your own publisher. Figure out how to leverage new technologies to affordably tell the stories you want told. If your goal is helping businesses refine their communications, consider targeting a specific industry, preferably one you believe in. Educate yourself on their business idiosyncrasies and offer solutions specific to their needs. If wedding photography is your passion, pick a target demographic and focus your business strategy on the unique desires of this group. If your business focus is working in your local community, get involved in that community. Find out what the economic concerns are and build a business that directly addresses those issues.

Photographer, educator, and business consultant Judy Herrmann posted the following on the ASMP Strictly Business Blog.

How many clients do you need? No, really—1,000? 500? 50? 10? If you're like me, the number's a lot closer to the right than the left. In fact, what I really need, what I really want is a core group of repeat clients who I like and respect and who like and respect my work.

If you're dying to be EVERYBODY's photographer, read no further. But if you, like me, are looking to build relationships with like-minded people with whom you can produce creatively satisfying work then I've got a crazy idea for you.

What if we stop scattering seeds to the wind in the hopes they'll land on fertile ground? What if we stop the mass mailings and e-mailers and broadcast marketing blasts that go to faceless, anonymous people who are already receiving thousands of these things from a multitude of faceless, anonymous photographers?

What if we take the time to find those individuals whose aesthetics and visual communications needs really resonate

with what we love to do. What if we took that common ground, mixed it with a little creativity, ingenuity, and good-old fashioned chutzpah, and used it to build relationships with those individuals instead of marketing to them?

Maybe, just maybe, we'd actually get what we want.[25]

The reality is that most independent working photographers only need a handful of customers to make a good living. What we need are loyal clients who value our unique product and compensate us fairly for it. Everyone does not have to think you or your work is extraordinary (and not everyone will). The goal is to find the good matches and nurture them with good work and exemplary service. This is the beauty of the Long Tail: we now all have access to inexpensive distribution channels for our images and our message and it is simply up to each of us to exploit these new opportunities to find our specific niche market.

Chapter 5

THE IMPORTANCE AND BURDEN OF COPYRIGHT

I have four Walker Evans photographs printed from original 8″ × 10″ negatives hanging on my living room wall. Most of the art in my home was acquired by the common and wonderful artist practice of trading work, but I purchased these Evans' prints directly from the Library of Congress for a minimal fee. These photographs, "Alabama Cotton Tenant Farmer Wife," "Home Interior, Alabama," "Wooden Church, South Carolina," and "Negro Church, South Carolina" bring me inspiration and joy every day. Evans took these photographs in 1936 while he was working for the Farm Security Administration (FSA). Because Evans created this work as an employee of the Federal Government these images have always been part of the public domain. Anyone can use these works for any purpose including Evans who published many of the images in his seminal book *American Photographs*. Did the fact that Evans did not enjoy the limited monopoly that copyrights give a creator hurt his career? Actually, the steady income and travel expenses provided by his job with the FSA made this work possible and the extensive and continual distribution that the public domain status afforded these photographs has propelled them to iconic status. Rather than harming him, this gig catapulted Evans' career and established him as a visionary in the genre of documentary photography.

Photographers can get very heated when court or legislative actions are threatening to change or weaken copyright law. Statements like, "They can't take my rights away," or, "It is my work and I own it, period!" are common sentiments. Well, yes and no. We need to know our history to fully understand the current cultural struggles related to copyright. This debate is central to our

future options as artists and demands your attention. As the Evans' story illustrates, control is not always a road to success. We need to rethink our relationship with copyright.

The Basics

When you create a photograph you are granted a bundle of rights called "copyrights" that provides you, for a limited period of time, the monopoly to exploit your work. It is incumbent on all artists to understand the basics of copyright and, by extension, licensing. Even if your personal choice is to create work for the purpose of sharing it for free with no restrictions, you need to understand how to make that possible. The law makes you the owner of your images and you have to take specific action for others to legally use your work, whether for compensation, attribution, or with no restrictions.

Ideas cannot be copyrighted. Only original tangible items can be copyrighted and, for us, that is a photograph. To be original, the photograph must be your idea expressed in a tangible form. A photographic documentation of a painting, for example, would not qualify as "original" and would not be copyrightable. An interior photograph of a room that happens to have a painting hanging on the wall is a copyrightable image. The photographer has interpreted a scene in creating the photograph. Copyrights give the creator the rights to reproduce (copy), modify (create derivatives), and distribute (publish) their creations.

There are three possible circumstances in which you will not own the copyrights to your photographs. And for each, there are precautions you should take.

Work Made for Hire (W.M.F.H.) Agreements

Sometimes called Work for Hire, these agreements state that the copyright to any work created for a specific project (as outlined in the contract) belongs to the commissioning party—not the creator of the images. Photographers who sign a "Work Made for Hire Agreement" supplied by the client relinquish their rights to the photographs and any future income from those photographs. Read

any contract before signing—some W.M.F.H. clauses are buried in larger documents. And remember, if you decide to take a job under these conditions, you need a clause added to the contract that allows you to use the images for your own self-promotion. Without that, you cannot legally put the images in your own portfolio or on your Web site. The client now owns the distribution rights to the images.

Unfortunately, W.M.F.H. Agreements are frequently attached to lower paid work. This contradiction of more rights demanded for less pay is a difficult conundrum of our industry. If more rights are being extended, the fees should increase. This is nice in theory but difficult in practice. Some publications and corporations demand these contracts as a condition of working for them. As an independent artist, you have to assess the direct financial benefit of doing the work and the less tangible benefits of being published in a specific magazine or exposure to a new clientele. Only you can make those decisions for your business, but I urge you to analyze these situations individually with a career strategy in place.

Robert Reck is an architectural photographer and regular contributor to *Architectural Digest*. All the work he produces for the magazine is under a W.M.F.H. Contract giving copyright ownership of his photographs to *Architectural Digest*. Reck does this work as part of his business and marketing strategy and it works. Multiple times a year, Reck has a lavish new portfolio piece in front of his business constituency and he is paid and credited to produce it. This work leads to the projects that provide Reck his true profit.

Employees

If you are an employee, your employer most likely owns the copyright to the images you create as part of your job description and duties. Check your employment contract to be sure or, in the absence of a contract, speak to the human resources department or an attorney. Try to negotiate the ability to use the images created on the job for your own self-promotion. You should do this at the outset of taking a staff position. Then if you leave the job or

are laid off you are not caught in the untenable situation of having no portfolio of work to market your services.

Transfers of Copyright

If you execute a transfer of copyright contract, you relinquish all your rights to the specific photographs designated in the agreement. Just as with W.M.F.H., without the new owner's permission, you cannot display or use the photographs in any way. Transfers of copyright should be done in concert with a premium level of compensation.

Most independent working photographers own the copyright to the vast majority of the images they create. Remember that unless you have taken one of the very specific actions outlined above, you own the copyright to your work. Currently the term of those copyrights is 70 years past your death.

Copyright Infringement

An unauthorized use of a copyrighted work constitutes copyright infringement. The copyright act does allow for **"fair use"** of copyrighted material providing an exception to the monopoly given to copyright holders. Uses considered fair use include parody, criticism, comment, news reporting, education, scholarship, and research. In addition, the intent of the use (commercial or not), the extent of the copy (part or whole), and the effect of the use on the potential income or value of the work are considered to determine whether a particular use is fair. Sound confusing? Nancy Wolff, intellectual property attorney, explains this dilemma in her book *The Professional Photographer's Legal Handbook.* "In the United States there is no list set in stone of what uses are considered infringing. The factors must be weighed against the facts in each case. We have guidelines instead of rules. As a consequence, it is difficult to give advice in this area. You can compare your facts to those described in previous cases to see if they are similar or not."[26] Fair use is really defined by case law and those decisions are not all in sync adding to the confusion over this issue.

Relevant History of U.S. Copyright Law

The United States Constitution Article 1, Section 8, Clause 8 states that the goal of copyright is "to promote the Progress of Science and the useful Arts, by securing for limited Times, to Authors and Inventors, the exclusive Right to their respective Writings and Discoveries." The framers of the Constitution called these rights out specifically to encourage the production of creative works, however, the intention was always for these rights to eventually expire in order for the work to benefit society as a whole. Siva Vaidhyanathan in his book *Copyrights and Copywrongs* elaborates on this strategy of our founders, ". . . they argued authors should enjoy this monopoly just long enough to provide an incentive to create more, but the work should live afterward in the 'public domain,' as common property of the reading public."[27]

For over a century, the maximum allowed monopoly was 14 years, then it was 28 years with the ability to renew for 14 additional years, and then in 1909 it was extended to 28 years with the ability to renew for 28 more. No changes in the statute were made from 1909 until 1976 and then the game changed.

The **Copyright Act of 1976** (which actually went into effect on January 1, 1978) extended the term of copyright to 50 years past the death of the artist and clearly defined that we own the copyrights to our photographs at the point of creation—the moment our idea is fixed to a tangible medium. Under the 1909 act, the emphasis on acquiring copyrights was commonly tied to publishing, and the images created on assignment were frequently presumed to be the property of the commissioning party. For professional photographers, this meant they likely held little or no claim to most of their published work. My professional career started in 1987, so this concept feels foreign to me, "you create it, you own it" is all I have ever known. The 1976 revision is frequently regaled as a victory for the independent working photographer opening up the possibility of licensing one image to multiple clients. An assignment image could not only yield the photographer a healthy profit at the point of creation, but if it was popular, newsworthy, or easily

applied to other purposes that same image could generate income long into the future. Stock photography blossomed at this point. Agencies representing photographers opened licensing the use of images on their behalf.

In 1989, the **United States joined the Berne Convention Treaty for Literary and Artistic Works**. This treaty requires that participating countries recognize the copyrights of work created by authors from other signatory countries. For example, if a United States photographer has an image published in a French magazine, the work is covered under French copyright law. For the United States, the significant change here is that published images no longer have to carry a copyright notice to have protection. We will discuss later, however, why attribution and copyright notice are still smart business practices. Prior to this treaty, any image published in the United States ran the risk of entering the public domain if it was reproduced without proper copyright notice or was left unregistered within five years of the first publication. Starting in 1989, these strict requirements were no longer necessary for a photographer to retain the full term of copyright on published work.

The Sonny Bono Copyright Term Extension Act of 1998 extended the term of copyright to seventy years past the death of the artist. The Disney Corporation played a large lobbying role in the passage of this act as its adoption extended the copyright term on Mickey Mouse to 2019. **The Digital Millennium Copyright Act** (DMCA), also signed into law in 1998, was constructed as an attempt to address technology advancements that presented challenges to the protection of copyrighted works, but technology was moving much faster than legislation, as attorney Nancy Wolff states.

"The DMCA is a complicated piece of legislation—at the time of its promulgation, technical corrections were already planned."[28] The act makes it unlawful to tamper with copyright management information (CMI). For photographers this covers things like watermarks on images or information embedded in digital files. The DMCA also provides a safe harbor for Internet service

providers, limiting their liability should they inadvertently host material being used without proper permissions from the content owner. Through the use of a take down notice sent to the Internet service provider hosting the infringing material, photographers can use this provision to have their infringed works removed or blocked from the Internet.

These revisions to copyright law, however, quickly became double-edged swords for photographers. It put us at odds with our assignment clients. Receiving fair compensation for our service has never been easy, but now creators have the additional burden of licensing the use of the commissioned images to the client paying the bill for production of these works. We have no choice in this. The law gives us the rights to our work and we must give permission to others in order for its use to be legal. The legal quagmire created by artists not conducting business professionally with proper contracts and licenses pushed companies to take matters in their own hands. The increased use of Work Made For Hire contracts and requests for all rights to our images is a direct result.

In **The New York Times vs. Tasini**, authors sued the *New York Times* for copyright infringement over the creation of electronic databases of articles licensed only for print publication. The Supreme Court ruled in 2001 in favor of the authors and the independent artist community celebrated a victory over a publishing giant. The party did not last long as the real result was quickly revealed when the *New York Times*, followed by publications everywhere, simply added "electronic rights" to their freelance contracts. Authors, photographers, and illustrators were faced with a choice, sign the new contract or do not work for these publications. Most could not afford to say no and this type of contract is now the industry standard.

The strengthening of copyright law and the Tasini case provide independent artists mountains of power according to the law. The bitter reality, nevertheless, is that this position goes to little practical use in the individual photographer's real-world life of client negotiations and business contracts.

Registration Is the Big Stick

When I first started registering my photographs with the Copyright Office, I cherry-picked images or projects based on my own assessment of their value. It turns out that I am not the best judge of what the market will like or use. I photographed a project ten years ago for an architect. The license clearly states no third party use. Fast-forward, I recently discovered these same images on various sub-contractors Web sites. These businesses did not have a license to use the work, making this clearly a copyright infringement. I did not register these images, however so my recourse is very limited. I can ask for the images to be removed by the Internet Service Provider via a Digital Millennium Copyright Act take down notice or I can send the sub-contractors an invoice. Neither of these actions is likely to generate a positive response or any money. No lawyer will be interested in my case and the amount I can collect if I pursue it on my own makes it an exercise in futility. Without registering the work prior to the infringement, I simply do not have the big stick to bring to the table.

In the United States, registering your work with the copyright office prior to infringement or within a three-month window after the first publication is necessary to have the full benefit of the law on your side. Attorney fees and statutory damages can only be collected if your work has been properly registered prior to infringement. More practically for all of us, registration gives us leverage. Since my paperwork clearly states that the license is not valid until payment has been received, a registration certificate included with a past due invoice can facilitate getting paid by delinquent clients. The certificate lets them know they have infringed my copyrights by using the work without paying me and my invoice quickly rises to the top of their priority list.

Registration signals that you care for and respect your photographs. I frequently hear photographers complain about disrespectful clients and consumers misusing their images. Well, guess what? If you are not registering your work with the Copyright Office, you are not respecting your work either. Registering your copyrights is the professional thing to do.

On top of registration, you should embed copyright and contact information into the metadata of all your digital files and, whenever possible, label your work. You are an independent working artist and you want to be found. Take the steps to do whatever is necessary to facilitate the association of your name with your images. Not only is this good for your business marketing and sales, but it protects you in this new digital economy in which electronic distribution is easy and abundant.

Orphan Works Legislation is an expected amendment to the copyright law. "Orphan works" are works protected by copyright law where the authors are unknown. Under the current copyright law, if the author cannot be located and the copyright status of the work is unknown, the work cannot be used without risk of cpyright infringement. This creates a cultural loss when museums and libraries holding archives of historic works are not using these items for fear of lawsuits over infringement. Legislation that allows for these types of "orphaned work" uses has the potential, however, to negatively impact the contemporary working artist. The specifics are unknown until the bill is written and enacted, but the intent of the change is to make unidentified work easier to use by lessening the recourse of the copyright holders. So, as a creator, you need to be prepared for this change by ramping up your professional practices of registration and attribution.

You, as a photographer, own the copyrights automatically when you create an image, but if you are a professional your work does not end here. You should register your work with the Copyright Office, embed contact and copyright information into every file and, whenever possible, seek attribution adjacent to your images. Treat your work with the professional respect you want to be given.

Out of Court Resolutions

The principle of copyright is laid out in the Constitution, so copyright infringement lawsuits are automatically a federal court matter. This makes the pursuit of legal action expensive regardless of the size of the infringement. Talk to any photographers who

have been through this process, even if they won, and they will tell you to do what you can to stay out of court. The process is exhausting and time consuming, and victory is never guaranteed. Here are a few examples of photographers who found satisfactory solutions outside of legal action.

Ray Fisher has been an ASMP member since 1961 and he is one of the all too rare examples of a photographer carefully managing the rights to his work. For decades, from his base in Miami, Fisher photographed personalities including royalty, presidents, entertainers, celebrities, and everyday workers. His body of work has proven to have lasting historical and cultural value. Fisher retains the rights to his work and thoughtfully and professionally collects royalties from the continued use of his archive in books, documentary films, and advertisements. Sue Dubois, Fisher's wife and business manager, prides herself on professionally negotiating reasonable fees for the use of Fischer's work. Even when they discover an unauthorized use, such as a memoir by Arthur Laurents that used a portrait taken by Fisher, she has succeeded in resolutions that yield them cash rather than expensive legal action.

Richard received a call one day from the publisher of *Pittsburgh Magazine*. He was upset that a photograph of a local musician that Richard created on assignment for them had just been published by another local journal in an advertisement for a concert. Richard knew nothing about this additional use of his photograph and did some research. Turns out the concert venue purchased ad space in the competing magazine, and the magazine's art director scanned Richard's photograph directly out of *Pittsburgh Magazine* and used it as the illustration for the newly created ad. Richard called his attorney, Mark Avsec, Esq., who asked him the question, "Do you want to get paid or do you want to make a point? You can't have both. If you want to make a point, it will cost you money. If you want to get paid, we will get you some money." Richard decided that for his client and himself he wanted to make a point. Avsec negotiated that the infringing magazine would publish an article he wrote titled, "Just Because You Can Scan It Doesn't Mean You Can Use It." Richard used the situation to satisfy his paying client and educate both the infringing party and the public.

Sean eloquently describes how he turned an infringing party into the key to access for a very significant personal project.

I had gotten a small grant from the Connecticut Commission on the Arts to photograph carnival workers and had gone down to West Virginia to spend some time. After a week or so I headed back, feeling that I had not done anything very interesting. At one point I got off the interstate and was taking byroads. I was driving through the town of Moundsville and saw this huge forbidding building. It was the State Penitentiary.

With nothing to lose, I went up and knocked on the door and asked if I could come in and take pictures. It seemed an audacious move, but to my surprise I was ushered into the warden's office. We talked for a bit, and then he told me I could go into the yard with a guard and take some pictures of anyone who was willing.

When I got home I developed my film and on it I found one picture that seemed dead honest. It knocked me out, and I thought to try to go back and take more, which I was allowed to do. I put together a group of pictures and submitted them to a photography magazine of the time, Camera 35.

A month or so after the magazine came out I got a letter with an ad torn from a newspaper. It advertised a TV report on prisons, and it used one of my photos under the provocative headline, "If you can't get a woman . . ."

I called ASMP and asked what my remedies were. I was advised I could probably get 175 bucks. That wouldn't do me much good, so instead I wrote to the station manager and implied that by the time I was done I would own the station. He was very apologetic and asked if there wasn't some way we could work this out.

I said that I might be willing to overlook the breach if they could use their contacts to get me into the system to photograph.

And within a week I was on my way South for the first of two week-long stays in a maximum security prison there. It really

added a huge amount to my take and was worth more than any $175.

And I think it was all part of the incredible luck I had throughout the whole project.

Benefits of Registration

- You have the full weight of the law on your side if you are infringed.
- You can file an infringement suit.
- You can more easily secure an attorney to take your infringement case.
- If you register your work prior to infringement (or within three months of first publication), you can ask for statutory damages and attorney fees if you win an infringement case.
- You can use your registration as leverage to get paid by defaulting clients.
- You have added protection against anyone claiming your work is an "orphaned" work.
- You are adding value to the services you provide your clients by protecting the investment they have made.

Reprinted with permission from ASMP.

The American Society of Media Photographers (ASMP) Recommended Best Practice for Registration

Register your photographs in "unpublished group registrations" using the online Electronic Copyright Office (eCO) system. Register your photographs prior to any distribution of the images. Step by step details are available at *www. asmp.org/copyright*

Copyright and Our Future

The term of copyright is the length of time authors are given the exclusive right to monopolize on their creations. When the term expires, the particular work becomes part of the public domain. Public domain status means the work is owned by the community at large and is unprotected by copyright. The first copyright law in the United States set the term of copyright at 14 years, today the term is life of the artist plus 70 years. This dramatic increase in the term coupled with the reduction in requirements to receive and maintain rights, has steadily strengthened copyright law in favor of copyright owners triggering a backlash from the user community. This is the struggle many call "the copyright wars."

Copyright holders, dubbed the "copy right" in this war, include unlikely bedfellows: the recording industry, movie studios, entertainment companies, publishers, software producers, stock photography distributors, illustrators, photographers, and writers. On the "copy left" we find libraries, academic institutions, consumer advocacy groups, research institutions, museums, and the individual consumer. Those on the "right" traditionally advocate for strengthening copyright law as a primary goal, and those on the "left" argue for free public access and feel the law has extended copyright beyond its original intent of fostering creativity for the greater good. Lawrence Lessig, one of the founders of Creative Commons and currently a Professor of Law at Harvard University, in an article for *The New Republic*, articulates the problems with both sides of this war: ". . . The two extremes that are before us would, each of them, if operating alone, be awful for our culture. The one extreme pushed by copyright abolitionists, that forces free access on every form of culture, would shrink the range and the diversity of culture. I am against abolitionism. And I see no reason to support the other extreme either—pushed by the content industry—that seeks to license every single use of culture, in whatever context. That extreme would radically shrink access to our past." The answer, as with most disputes, can be found in the middle. And I believe it is critical for independent working artists to take notice of this issue. Lessig continues, ". . . We need an approach that recognizes the errors in both

extremes, and that crafts the balance that any culture needs: incentives to support a diverse range of creativity, with an assurance that the creativity inspired remains for generations to access and understand."[29]

David Carson, General Counsel for the U.S. Copyright Office, was a panelist at The April 2010 ASMP symposium "Copyright and the New Economy: Issues and Trends Facing Visual Artists," where he described the archaic condition of our current copyright law.

"Most of the law we have right now was written in the 1960s. It was written in a time when copyright was a system that regulated the activities of a well-defined group of people. It didn't touch the individual citizen. The individual citizen was never in a position to be infringing a copyright, most citizens were not in a position to create content that is protected by copyright." Today, nothing could be further from the truth. Technology has democratized creation and distribution, so not only can everyone make something, everyone can publish. Our current laws are complicated and unusable in this age of sharing and remix that we all use daily and seamlessly. Professor Lessig, at this same ASMP symposium, stated the balance he believes we need to find, "The copyright system needs to both support the professional, but assure a sufficient freedom for the amateur, both of these, not either. It is not enough to protect the professional if that kills the amateur, and it is not enough to liberate the amateur if it starves the professional."

What does this mean to the professional artist? First, we need to change our attitude about copyright. We need to acknowledge that there is a substantive difference between a student using parts of a photograph in a collage created for art class and a company using the same image to sell a product or service. The law does not clearly make that distinction, but we can by our actions. As the copyright holder of your work, you can act reasonably in ways that benefit you and the community at large by acquiring compensation for commercial use and giving consent for non-commercial use. I believe that giving on the non-commercial use will add value to each of us, add value to our work, improve our individual brands, further the development of quality in our culture

at large, and, most importantly, it will squelch the call of the "copyright abolitionists." If photographers, as a group, take the rigid position of maintaining copyright as it is today, the extremists on the other side of the spectrum will get stronger. And, in case you hadn't noticed, we are outnumbered.

Corporate control of content is a growing dilemma. Remember, Disney is the lobbying force that ensured the passage of the Sonny Bono Copyright Extension Act. It is the entertainment industry that has threatened consumers for remixing cuts of songs into videos of their children dancing where the intent is nothing more than a desire to show the clip to fellow family members. Corporate strategic efforts to control the users of new technology not only fail, they create a complete disrespect, even contempt, for copyright law. These actions make it harder for us to maintain respect for the rights we hold to our own creative works.

As mentioned earlier, the difficulties of managing the idiosyncrasies of rights means that many corporate interests prefer to simply own what they commission. Add to this the sad fact that too many photographers have held clients hostage with extremely high re-licensing fees or, worse yet, license an image created for one client to that business' direct competition. This translates to an increase in requests for photographers to relinquish their rights as a condition of doing work for a company. Not only does this type of behavior damage our reputation as professionals, it destroys the long-term ability to own our work and increases the amount of corporate owned creative content. Professor Lessig in his book *Remix* speaks to this concern.

> *This trend away from artists owning their own creations is not new. It has long been a part of commercial creativity. In America, for example, the 'Work-for-Hire' doctrine strips the creator of any rights in a creative work made for corporations, vesting the copyright instead to the corporation. This is an awful trend, fundamentally distorting the copyright system by vesting copyrights in entities that effectively live forever.*[30]

This is not a new story, but it bears repeating—the creators of the content, which is in demand and fought over, are frequently

not the largest benefactors of their own labors. The current way of doing business is clearly not working for us and we need to change. It is incumbent upon us, as creators, to build solutions that ease these business transactions and allow us to more frequently maintain the copyrights to our own work. If all of our work becomes work-made-for-hire, the prices paid for our work will be driven down even further and we will lose control over how our work is used both in the commercial and non-commercial spaces.

Artists are stuck in the middle of this copyright struggle and a balanced and reasonable resolution is in our best interest. Our interests are not the same as the major corporate copyright holders and our interests are not the same as the groups wanting free access to everything. We have been leaning to the right on this battle and it is time to move toward the center or we will lose the ability to profit from our work.

Chapter 6

LICENSING IN THE NEW ECONOMY

Build a business that satisfies your clients' needs and you will succeed. William Patry, in his book *Moral Panics and the Copyright Wars*, articulates how I believe photographers need to think about their place in the new economy.

> *Businesses create and keep customers by satisfying customers' needs, and thus it is only through satisfying customers that businesses can make money. Focusing on satisfying consumers rather than on controlling them (or suing them en masse) requires businesses to devote themselves to figuring out what consumers want and value, and to then cater to those wants and values.* [31]

Sounds obvious, right? As a group, however, we have not been acting on this basic business truth.

Sean Kernan humorously describes what frequently happens in our client relationships. "Let's say you go to a restaurant and order a roast beef sandwich. The waiter brings you a goat cheese salad with the explanation, 'I know you will love this.' You may love it, but you will still likely never return to that restaurant because they did not deliver what you asked for." We need to acknowledge that our industry business models are frequently not meeting the needs of our clients and that this is fundamentally disastrous for all of us.

As discussed in chapter 4, the old ways of marketing do not work in today's new online dominant economy. Our clients are utilizing multi-platform tools to publish and sell to increasingly smaller market segments. A single targeted message to one constituency will likely need to be repurposed and delivered via print and electronic advertising, online social media outlets,

mobile devices, direct e-mail, direct postal service mail, Web sites, in store displays, blogs, and pushed to the news media through public relations. This list is not exhaustive as there are new outlets for messaging being developed all the time. Herein lies the difficulty for the working professional; we own the copyrights to our images and, therefore, we must execute a license to our clients that gives them legal permission to use the photographs. But in today's marketing model of advertising over endless and growing platforms, how do we structure a license that works for us and for our clients? The answer is that we have to compromise. It is true that an individual photographer may be able to maintain strict licensing terms and high fees, but the ability to do that will depend on the individual's clout and the particular situation. The reality is that the majority of us compete daily in a business climate in which free and easy rights acquisition is the norm. As we discuss licensing remember that flexibility is a sign of strength not weakness. The balance is found by structuring your business to fulfill a service your clients need and make a profit by achieving fair compensation for the rights being granted.

One too-frequently embraced solution professional photographers use is simply avoiding the licensing conversation. A client calls, asks for a price to execute an assignment, a price agreed upon, the project photographed, delivered, and invoiced. No mention of a license in the conversation or the paperwork (if there was paperwork). These photographers tell me, "I don't want to deal with licensing or copyright, it is too hard, I just do the work and let my clients use the pictures for whatever they want." However expedient this approach may seem, it is not professional and you put your business, your work, and your clients at risk. The copyright law states that we create intellectual property and, like it or not, as image makers we are engaged in licensing. A license exists in the scenario described above—it is simply an "assumed" license, which can frequently lead to trouble. Besides producing high quality photographs, it is our obligation to professionally price and license what we create. This is the business we are in.

Licensing and Pricing Basics [32]

A practical methodology for determining your price and a judicious way to execute the license for the use of your photographs is critical to your business success. It is fundamental to the business we are in that we understand what it is we sell.

The business of professional photography is broken into three main categories of use: commercial, editorial, and retail. Commercial refers to photography that is used to sell or promote a product, service, or idea. Editorial refers to photography used for educational or journalistic purposes. Retail refers to photography commissioned or purchased for personal use.

The difference between these categories is not in the type of photography, but in the use of the images. For example, a corporation hires a photographer to document a product launch event. For the corporation, the type of photography being commissioned is event coverage, and the use is commercial because the corporation will use the photographs to promote their new product. For a local newspaper covering the same product launch, the use would be editorial. An example of retail photography would be a wedding, which is also event coverage—but now the work is categorized as retail because the end use is personal. While some photographers concentrate in one of these three areas, it is not unusual for a photographer to work in multiple arenas, making it imperative to understand the business practices and pricing structures of each.

There are two ways for clients to obtain a license to use images: by commissioning a photographer to fulfill a specific request, commonly called assignment photography, or by licensing the use of an existing image, known as stock photography. Many photographers license their images in both ways, and much like the three types of uses discussed above, each has distinct business norms of which you need to be aware.

Assignment photography is primarily a service business that creates photographs. Assignment photographers are

Licensing

There Are Two Ways to License Photography

Assignment

A photographer is commissioned to fulfill a specific request.

EXAMPLES

Independent photographer hired directly by the end user

Independent photographer hired by a representative of the end user

Stock

Licensing the use of an existing image.

EXAMPLES

Distributors

Direct licensing to independent photographers

All Uses Fall into One of Three Categories

Commercial

Photography used to sell or otherwise promote a product, service or idea.

EXAMPLES

Paid media advertising
• Print ads
• Web ads
• Billboards

Corporate
• Public relations
• Annual reports
• Product packaging
• Web sites
• Brochures

Business to business
• Brochures
• Web sites
• Product packaging

Editorial

Photography used for educational or journalistic purposes.

EXAMPLES

Textbooks

Encyclopedias

Editorial content in
• Online news sources
• Magazines
• Newspapers

Retail

Photography commissioned or purchased for personal use.

EXAMPLES

Weddings

Family portraits

School portraits

Fine art prints

The Scope of Use Determines the License

License

A legal agreement granting permission to exercise a specified right or rights to a work.

predominately independent photographers hired directly by the end user or by a representative of the end user, like an advertising agency or design firm.

Stock photography is a commodity business, dominated by a handful of large distributors, each selling photographs that already exist. These companies license photographs they own through Work Made for Hire agreements (keeping the entire fee), or license photographs they represent (paying royalties back to the copyright owner). Independent photographers can also license their images directly to clients—without going through a distribution company —retaining the entire fee.

Here are some examples that illustrate the importance and power of licensing your work and retaining your copyright:

- A photographer is hired to photograph a building for the owner of that building. The images are licensed for very broad use allowing the owner to market the rental spaces available in a variety of media. The license clearly defines that the rights are granted only to the building owner. A month later, the architect approaches the owner about obtaining some of the photographs for her Web site. The owner, because the terms of use were clearly defined, correctly refers the architect to the photographer, who is able to generate income from these existing images through a new license to the architect.

- A photographer is commissioned by a trade magazine to photograph a corporate CEO for an editorial piece on the company. The publication licenses one time North American print rights and editorial worldwide Web use exclusive for six months. A year after the project the CEO is indicted for fraud and pictures of him are in great demand. The photographer is able to re-license this portrait many times over in various editorial outlets.

Any conversation on price has to begin with the fact that no photographer is working in a bubble. Business location, the state of the economy, the prevailing fee structure for a specific type of photography, and the uniqueness of the request all effect what you will be able to charge.

Here are a few examples highlighting the impact a specific market can have on your price:

- A photographer working in a large metropolitan area will have higher expenses and production fees than her small-town counterpart. The basic cost of running a business—studio rental, models, transportation, food, and assistants—are simply higher in a city.

- A photographer in a remote, less populated area, hired by a national magazine to cover a local story, will likely be able to demand higher fees than his city counterpart simply because the editor has fewer options. The lack of competition gives the remote photographer an advantage.

- A photographer working in an area where the economy is manufacturing-based has likely seen fees stagnate and even drop, while a photographer located where the dominant industry is healthcare or technology has fared much better. Economic conditions will affect what can be charged.

Photographers price their work based on the creative and production needs of each project, combined with the specific use of the images. In other words, the exact same image will be priced differently based on the unique needs of a given client.

Let's consider an image of a girl playing in her backyard with her new puppy. The parents of this child purchase from the photographer a print of this image to hang on their wall. This is a retail sale with a license for display use only and would likely yield the photographer a modest fee. Same photograph, but this time *Time* magazine wants to license the image for a story on growing up in America. This is an editorial license and would bring in a modest fee likely based on pre-established rates by the publication. Looking at this image one more time, let's say Apple Computer wants to use this image in a campaign for a new product. The image will be used extensively in print and electronic media. This license would generate the photographer a fee many times higher than the other licenses. The exact same image licensed for three different purposes yields three different fees. The use is a large determining factor in the price. This makes sense—the

parents who simply want to enjoy this photograph hanging in their home should pay substantially less than Apple Computer utilizing the image to sell a product.

Production needs of any assignment are another factor affecting price. For example, is a permit needed to shoot in a specific location? Are assistants needed? Will special props or a stylist be used or will you use what is on-site? Are you lighting to document the subject or create a mood? Is an extreme time of day necessary to achieve the requested objective? All these things and many more should be considered when pricing the production end of any assignment.

Putting this idea in real terms, a client may call and request a quote to create an image of an outdoor cafe showing a person enjoying a cup of coffee while reading a book. This may initially sound simple, but the client then adds these parameters: the location must be a specific outdoor café, at dusk; specific furniture must be used that is different than the style used by the café; it must look like it just rained; and the café must contain lots of fresh flowers; the person needs to be a woman in her twenties, wardrobe options business to casual, brown hair, modest make-up. These requirements make this photograph a high-production image and the cost should reflect these requirements. Regardless of use, the cost of this image just increased significantly.

Usually, but not always, a project with high production expenses will have higher licensing fees. This is simply practical— few clients want to pay for elaborate sets, models, or props unless the image is going to be used extensively. Generally, a client's early production requests are an indication of the photography budget. For instance, if the client answers every production-related question with, "No, we will just shoot what is available when we get there," you have just been given a tip that the budget is small.

Production questions answered with, "At this time we don't know," mean you will not be able to accurately quote the job. You can offer ranges or a best estimate, but it's necessary that all numbers should be qualified on your paperwork (estimate) to cover this lack of information.

Steps to Determining Price

Assignment Pricing

Price = Creative Fee + Expenses + License + Market

Creative Fee	Your Cost of Doing Business (CODB) plus the unique factors of the specific project being priced.
Expenses	The specific production costs of this project.
License	The legal agreement granting permission to use the image(s) being commissioned. The higher the use the higher the price.
Market	Learn what price the market will bear for the specific type of photography you are pricing. Research information on the client. Consider the macro and micro economic climate conditions specific to the client and the geographic region.

This process may initially feel daunting, but, with a little patience, once you have calculated the fees and expenses for a few projects, you will develop the skills and experience to do this efficiently—and with confidence. For each project you are pricing you must calculate the *creative fee*, add in the *expenses*, establish the *license*, and consider the *market*. Here are the details for each of these steps.

Creative Fee

Use your Cost of Doing Business (CODB) as the starting point. This number establishes your own minimum income needs to cover your non-reimbursable business expenses and draw a salary. Once you know your CODB, you can then factor in the particulars of a specific assignment to determine your total Creative Fee.

Your CODB is easy to calculate. The formula: Non-reimbursable Expenses + Desired Salary = Your Total Annual Overhead ÷ Number of Billable Days (can use annual number of assignments, or portraits or weddings, whatever best indicates your billable unit) = your CODB.

Do not confuse non-reimbursable expenses with expenses you bill to a client for a specific project. Non-reimbursable expenses are the costs of running your business. Examples include

rent, computer, phone, Internet access, insurance, equipment purchases, office supplies, repairs, utilities, server hosting fees, accountant, bookkeeper, taxes, depreciation, replacing equipment, Web hosting, subscriptions, membership dues, marketing budget, and saving for retirement.

Most of us, naturally, want our desired salary to be as high as possible, but it is important to be realistic and practical. Base this number on a small increase in your salary from the prior year or, if you are starting out, put your salary in at a level that can support your current cost of living. If you do not know your cost of living, you need to calculate that first.

How do you determine your annual number of billable days or billable units? Look at past years or, if you are doing this for the first time, talk to fellow photographers. Remember you need to allot time for marketing, portfolio development, and administrative work. These are all critical to your business, but they are not billable days. Most assignments need pre- and post-production time, plus you need a vacation, and keep in mind that few projects are scheduled around major holidays. As you will quickly recognize, there are only 44 to 48 weeks a year to consider. Depending on the type of photography you are doing, this number may vary dramatically. A photojournalist might complete multiple assignments in a week, while a photographer working in the commercial arena might only complete three to six assignments a month. A photographer doing larger production projects may do only six projects in a year, compared to a wedding photographer who might be able to book 15 weddings annually. Many photographers do a mixture of project types and sizes, which is why calculating your CODB by number of "days" you expect to work is helpful. Once you have your daily photography CODB number you can simply multiply that by the number of days for a given project to determine your minimum fee to take on an assignment. If your CODB is $1,200 and an assignment calls for three days on location, the starting point for your fee is 3 × 1,200 or $3,600.

Pricing below your calculated CODB means you are losing money on any given project. Naturally, some business common

sense has to be considered. For example, an editorial assignment may be a good business decision, even though the pay scale is lower than commercial work. A particular assignment may offer you access to people and places you want to photograph, an opportunity to produce a great portfolio piece, or additions to your stock library. You cannot, however, take repeated jobs that fall below the CODB without getting into financial trouble. Like any business formula, it is necessary to be flexible and smart.

When estimating an assignment, the final step in determining your total creative fee is to take your CODB and add to it any fees for the particular needs of the project. Your CODB will stay relatively consistent, but the creative needs of each assignment can vary dramatically. This is why one creative fee does not fit all jobs. Using the job example above, if the client for this assignment was seeking my specific lighting style, I would raise that fee by 50 percent to $5,400.

Here is a sampling of items to consider when arriving at your total creative fee; tight deadline, specific style, creative solutions needed (looking for conceptual input), expectations of high end service (catering lunch rather than going to a local McDonald's), logistical difficulties (for example, a factory that cannot stop production), experience, extreme limits on subject availability (like two minutes with the CEO for a portrait), technical expertise, geographic location, or reputation. If any of these things are critical to the successful execution of the job or important to the client, they should increase the fee. All these things have value and should be reflected in the price. If the production needs of the job are simply not remarkable or the photographs needed are generic, there is a limit to how much your fee will go beyond your CODB, if at all.

Remember, non-subject specific advertising and marketing photographic needs are mostly met through existing imagery only a click away via a multitude of online sources. Furthermore, employees or interns with cameras now, more often than not, cover mundane image needs like headshots or event coverage. The increase in non-professional competition for these commonplace

photo needs has driven the price for this type of work down making it a less viable option for building a sustainable business. There is no reason to not quote these types of projects when asked, but you should be aware of the competition and strive to sell value through a special service or options such as a quick turnaround multimedia show of the event, or onsite portrait selection from your iPad. The images for this type of assignment may not be special, therefore you have to make the experience extraordinary to show the potential client the value of hiring a professional.

A Note on Using a Day Rate Pricing Model

A photographer's CODB is not a day rate for services. It is an internal number used to ensure you are pricing projects to yield a profit. Time is, of course, a factor in determining your creative fee, but it is only a factor based on your experience and expertise. Pricing based on the day or the hour punishes you when you gain experience and work faster or purchase better equipment. Efficiency should demand a higher fee not a lower one. Creative works are rarely completed on a time schedule; so do not price your services as if they are. Instead, price your services per project or per image and take the clock watching out of the equation. If all elements of a session fall together quickly and you complete the job early, your client will be happy and you will not lose money. You delivered what you were commissioned to create for the agreed upon price.

When I started doing assignment photography, I used the day rate system to set prices. Early in my career, a small advertising agency hired my business partner and me to photograph a factory for a capabilities brochure. We committed to being on site for one day at our "rate." When we arrived the art director split us up and had us both photographing in different parts of the plant. He knew we were both capable photographers and worked as a team, but by sending us off in different directions he got a two for one. For a single day rate, the client received two days of photography. The pricing for this project should have been the guarantee to create a specific number of images while on site for up to one day.

When photographing weddings, parties, or corporate events, it isn't feasible to place limits on the number of images being created, so you should protect yourself by pricing for "up to" an agreed upon time on site. Making it clear that you will be on site for up to four hours for X dollars, you guarantee the job stays profitable. Should you be sent home after three hours your price remains what you quoted. Conversely, if you are asked to work beyond the specified time, you can charge a previously agreed upon fee for the additional time.

These conditions, I believe, should be the same regarding fees for digital post-production and retouching. To charge by the hour punishes you for proficiency. Base your fees for these services on the quantity of images and specific requirements of the project just like your creative fees.

The License

The Picture Licensing Universal System (PLUS) is a nonprofit initiative created to help users and creators clarify and standardize the image licensing process. PLUS defines licensing as, "A legal agreement granting permission to exercise a specified right or rights to a work, often encompassed in an invoice, or the act of granting same."

The license is a necessary step when completing an assignment or selling the use of an existing photograph. Whether this step increases the price depends on the parameters of the license. The license will never reduce your calculations from the creative fee process, but if the use of the image is minimal or the work mundane, the license may not take the price up. Regardless, the license is a critical step to fulfilling your job as a professional.

What is the client going to do with your photograph? Is the use commercial, editorial, or retail? You need this information to determine whether the client's needs for the images affects the price and to write an appropriate license for that use. Typically the larger the audience for a specific project the higher the fee attached to the license. For example, a photograph used across various media for consumer product advertising would dramatically

increase the total cost of the project, but a one-time use license for a photograph illustrating a trade publication article would likely be a flat liner on the photographer's price, meaning the profit margin in your project-specific creative fee is the only profit you will make on this particular job. This is not a problem if you accurately calculated and adhere to your CODB which has a base salary built into the figure. This is all the more reason to follow this basic business guideline when pricing lower end use jobs.

In general, more use means a higher fee, so it is possible for a photograph, executed with minimal expenses or expertise, to generate an extremely high licensing fee. The point here is that the use, not what it took to create the image, has overwhelmingly determined the price.

Photographers differ on how they illustrate their pricing to clients. Some separate creative and licensing fees, others lump everything together. Regardless of how you break out your price to your clients, it is critical that you calculate the price by considering both distinct fee areas.

Writing a License

The license outlining how your client can use your images from a given project or stock sale should be included in all the paperwork (estimate, assignment confirmation, invoice) and embedded in the delivered digital files. PLUS recommends that a license be written in a list format and include the following information.

- Parties (client/photographer)

- Media Permissions (uses permitted in this license)

- Constraints (time limit of the license)

- Requirements (credit line or any other agreed upon requirements)

- Conditions (the terms and conditions of doing business with you, usually printed on the back page of most paperwork, templates available on ASMP.org)

- Image Information (your unique image identifier)

- License Information (client's purchase order or other project identifier)

It is important to write your license as a list not a paragraph. The list format reduces the likelihood of misinterpretations due to clumsy sentence structures.

Production Needs of the Job—the Expenses

Carefully add up all the expenses needed to complete the job you are quoting. Ask lots of questions and make sure all the details are covered. Once you accept a job at an established price, you will rarely be able to increase the expenses with the excuse, "I didn't think of that."

Always remember that each job is unique—make no assumptions when pricing a job. Even if you are not in doubt about a detail—ask and confirm it. With practice, you will find that you are frequently reminding the client what is needed or taking care of a detail he didn't even consider and, in the process, you are instilling confidence. If you are questioned about all of your inquires, assure the client that this is the only way you can provide them numbers that are realistic. You ask the questions now to make the assignment run smoothly and stay on budget throughout the project.

Expenses are typically billed with a mark-up. This is a customary and expected business practice. When preparing your estimate, make sure you add the mark-up to quotes you are given from vendors. High production advertising projects commissioned by advertising agencies are an exception to this rule. These jobs frequently require you to submit actual receipts for any expenses. Ask this question when preparing an estimate for an advertising agency. If the answer is yes, make sure to factor handling all the services generally built into your expense mark-ups in separate pre- and post-production fees. Handling booking models, arranging for lunch, and a myriad of other details has to be done by you, your assistant, studio manager, or producer, and that time has to be covered.

I recommend you set established charges for expenses that are consistent, for example a Web gallery, master file preparation or online image delivery. You should also evaluate those charges annually and adjust as needed to ensure you are covering your costs and generating a profit on these services.

Here is a partial list of possible expenses for a photography assignment.

- Equipment rental
- Digital processing fee
- Proofs/Web gallery
- Retouching
- Master digital file
- Repurposed digital files
- Prints
- Archiving
- CD or DVD
- Image delivery
- Assistant
- Models
- Casting director
- Wardrobe, prop, or food Stylist
- Hair and/or make-up artist
- Location scout
- Carpenter
- Set Designer

- Props—purchase/rental
- Background
- Location rental
- Wardrobe
- Catering
- Trailer rental
- Permits
- Hotels
- Airfare
- Mileage/tolls/parking
- Car rental
- Customs/carnets
- Gratuities
- Meals
- Misc. supplies (for example: tape, bulbs, gels)
- Messengers
- Shipping

Tips for Determining Price

Learn what price the market will bear for the specific type of work you are pricing. By the term "market" I do not mean the general state of the economy, but rather the unique qualities of a particular

client, job, or type of photography. Wedding photography in Miami Beach is a market distinct from wedding photography in Ft. Wayne, Indiana. Editorial work for business trade magazines is a market distinct from editorial work for small-town newspapers. Product packaging photography for an industrial manufacturer is a market distinct from packaging for a high-profile consumer product producer. Consider not only the geographic and economic conditions of the client, but also the photo industry standard for a particular level and/or kind of work.

If you discover that your cost of doing business is dramatically higher than the prevailing fees charged for the type of photography you want to do, you must reevaluate your business plan. For example, if photography is your only means of support and you want to be a journalist, do not plan on having a large studio or driving an expensive sports car. Either change your overhead and salary goals—or change the type of photography you are doing. There is no way to build a sustainable business if these two financial aspects are consistently out of sync.

Use the Internet to get detailed information on your potential client. You can learn a great deal by simply doing an Internet search of a company name. This should be your first stop when someone calls asking for a quote. If it is a third party calling, ad agency, or graphic designer, make sure you get the name of the ultimate client. You can research both the party calling you and the end user. Frequently, when hired by a third party, you will be billing that agency or design firm, so it is important to know the legitimacy of their business, too. The client actually using your images, however, is the primary consideration when determining your price.

When viewing a prospect's Web site look for:

- How much photography do they use?

- Is the photography on the site professionally done?

- What is their preferred style? Are you a good fit?

- How well designed is the site?

- What do they do or sell?

- How large is the company?

- How long have they been in business?
- Where is the headquarters?

Probably the most important market consideration when pricing photography is the industry practices for a particular kind of work. The photography industry is made up of various strata of work. For example, the following project types each have distinct client expectations and pricing norms.

- Story for a national consumer magazine
- CEO portrait for a trade magazine
- Event coverage for a corporation
- Architectural photographs for an architect
- Product illustration for a manufacturer
- Packaging photograph for a consumer product
- Annual report photography for a Fortune 500 company
- Advertising photograph for a consumer product

Fellow photographers are your greatest resource for appropriately evaluating where a particular job falls on the spectrum of service and price. Build a personal network you can rely on. Finding peers who will give you candid and honest information takes time, but it is an essential ingredient to understanding your market.

My fellow ASMP members have served as my business network. The large access to other professionals that my trade association provides allows me to contact a photographer outside the market I work in, immediately eliminating the fear of competition factor that sometimes makes it tough to share information. Not every photographer is open to this kind of networking, but if you get a cold shoulder do not despair. Simply call someone else. Just like pricing a service you need for your home or making a financial decision, it is best to get more than one opinion. And remember to return this favor when those starting out come to you.

Other photographers are particularly helpful when the work you are doing shifts from one type of market area to another. For example, if you have been doing corporate communications work

and then have an opportunity to quote an advertising job for a new prospect. The business norms and expectations for these two types of work are very different and if you severely under quote the higher valued advertising work, the client will likely infer that you lack the experience or the savvy to take on the project. Most photographers do not engage in "lowball" pricing on purpose. More often, pricing out of sync with the prevailing norm for a particular type of work is the result of ignorance. Educate yourself and price to build a sustainable and successful business.

Selling Your Price

As photographers we are confident skilled visual communicators. When it comes to pricing our work we may lack, in equal measure, the skill necessary to articulate our pricing structure in a clear and concise manner. Talking about price can be uncomfortable for us. However, when we are confident in how we determine our fees, it translates to assurance for our clients that they are receiving appropriate value for the price. You will have confidence in your pricing if you know your actual costs and the unique value that you bring to a project. Pricing is a negotiation and it's important to recognize it is a process to arrive at a mutually agreed upon price. For example, if you quoted a product shoot and your price is higher than the client wants to pay, suggest they do two views per product rather than three. Or keep the background consistent in all photographs rather than changing it out for each subject. By offering solutions that require both you and the client to give a little, you can reach a respectful accommodation. Through this give and take process you will be strengthening a relationship with your client.

Fair compensation for the rights granted is the goal of any assignment negotiation. As discussed, that price is dependent on a number of factors, from creative fees to production needs. The most contentious factor, however, is clearly the right to use the photograph—the actual license.

In the previous chapter, I detailed the issues revolving around copyright. Photographers and other creatives generally understand

the importance of copyright to the work they produce. The reaction we have to a client questioning the license may put us in a defensive position, and we may assume the client knows nothing about copyright law or plans to battle us on our rights. It's been my experience that these assumptions are often wrong and are an impractical way to approach the problem. The best course of action is to keep the conversation positive by focusing on the client's needs and concerns, respectfully articulating that you will structure a license that fits the requirements and budget of the assignment.

Tips for Working with Editorial Clients

Publications frequently have a standard contract for hiring photographers to fulfill editorial assignments. Typically, these contracts ask for very broad usage rights (especially considering the pay scale being offered). Some publications are flexible and the terms of these contracts can be negotiated.

The ability to negotiate successfully for improved terms and rates will depend largely on your relationship with the editor, your reputation, the urgency of the assignment, and the special qualifications or benefits that hiring you will afford them. For example, if you are traveling in a remote area and an urgent story arises close by, you are in a strong position to change the contract and raise the rate. Conversely, if you are in a large metropolitan area being asked to cover a story that is not time sensitive or "special" to the editor, your negotiating position is weaker.

Tips for Working with Advertising Agencies and Graphic Design Firms

Traditionally, agencies and design firms negotiate terms and fees directly with the photographer on behalf of their clients. The actual license, however, grants rights to the end user of the images—the ultimate client. Estimates and invoices are generally sent to and paid by the agency or design firm, not the end user. It is a normal trade practice for agencies and design firms to mark up the photographer's fees just as photographers mark up services, such as models, stylists, and digital services.

When working with an advertising agency, the art buyer is generally the person who vets photographers and collects the quotes on any given assignment. In the absence of an art buyer, the art director or creative director will contact the photographer. Either way, it is important to learn about the client and how the images will be used in order to prepare a quote.

Graphic design firms are frequently smaller operations, and the designer on a given job is usually the photographer's contact person. Again, you will want to ask for details on the client and how the images will be used to provide a quote.

A Note on Licensing Stock Photographs

There are two factors to consider when pricing a license for stock photographs: the uniqueness of the image and the terms of the license (how the image will be used).

Stock photographs are predominately sold through online distribution channels. Whether large mega archives like Getty and Jupiter Images or, at the other extreme, an independent photographer's Web site, the Internet is the vehicle for most stock photography sales. If a photographer places work with a distributor, there is a signed contract giving the distributor the authority to set the prices and transact the sales. The photographer is sent a contractually agreed-upon percentage of each sale.

Licensing stock imagery directly eliminates the middleman and the photographer keeps the entire licensing fee. That may sound great, but stock photography is very competitive and the difficult part of being independent is marketing your images. Just as with assignment work it comes down to sales and negotiations.

Licensing for the New Economy

It is rare these days to license photographs, particularly images created through commissioned assignments, for a single use. The new norm is to bundle rights allowing the licensee to use the images over a broad spectrum of platforms. This shift is critical for

our clients as the old ways of marketing discussed earlier are dead. This shift is critical for photographers, too, offering us a way to preserve the copyrights to our work while simultaneously meeting the needs of our clients. We must, as producers of creative content, make the licensing process efficient and understandable. If we do not do this, the proliferation of Work Made For Hire agreements and rights grabbing contracts from our clients and publishers will dominate, if not take over, the creative market.

Generosity to our assignment clients is necessary. For all the reasons articulated earlier, there are simply not as many clients commissioning professional photographers as in the past. We should all treat those who do with the special care they deserve. Our clients need broad use of the images we create for them, but they do not need to own the copyrights. An unlimited use license, even with no time limit, is still a license. That license grants to that one person, business, or corporation the right to use the images for their own purposes. It does not extend to them the right to share or license the photographs to anyone else. As the creator and owner of the photographs, you control any further use or distribution of the images.

Most importantly, we must still price by taking into account the extent of the usage even if we no longer know the "exact" parameters of that use. Focus on the size of the company and their marketing channels. A mom and pop diner advertising on their Web site and in the local paper should pay far less than a global corporation with multiple online and print outlets. More use still equals a higher price. This is simply common sense, and while we cannot measure the uses as absolutes, we can achieve fair compensation for the rights granted.

This reasonable approach to solving our commissioning clients' problems will take the wind out of the sails of corporations claiming they do not want to be "held hostage" by large re-license fees or get sued because of sloppy rights management. No longer will a rights grabbing contract be the only solution to these corporate complaints. Some will still want complete control, but if we offer a

reasonable solution at a fair price, the desire to "own" the work created for these entities can move back to a very premium price point where it belongs.

Attribution attached to the use of our work has long been offered to photographers in exchange for fair compensation, particularly in the editorial world. And the traditional industry response has been, "I can't pay my rent with credit lines." In the new online publication space, however, we need to rethink the importance of attribution. If attribution became the standard in online publishing and that credit line links back to our Web sites, each additional use of our work will increase our search engine standing and our exposure. Artist name attached to image should be ubiquitous making it simple for us to connect with potential clients and publishers. Attribution should not replace compensation, but its importance in the online publshing world should not be dismissed.

As client driven projects lessen, more and more photographers will be producing their own projects and seeking outlets to monetize that work. As we become producers and publishers our control increases and with that our responsibility to both protect our work and facilitate its commercial use. All work needs to be registered with the copyright office, all work should carry embedded and external attribution, and all work should be in a searchable database. This isn't a dream—it is nearly reality.

There are two important nonprofit groups coming at this issue from divergent yet complementary points of view. Founded in 2001, the **Creative Commons (CC)** defines itself as, ". . . a nonprofit corporation dedicated to making it easier for people to share and build upon the work of others, consistent with the rules of copyright. We provide free licenses and other legal tools to mark creative work with the freedom the creator wants it to carry, so others can share, remix, use commercially, or any combination thereof." The Creative Commons reports that, as of April 2010, there are 350,000,000 CC licenses attached to objects on the Internet.

The Picture Licensing Universal System (PLUS) Coalition was founded in 2004 and describes itself as, ". . . an

international nonprofit initiative on a mission to simplify and facilitate the communication and management of image rights. Organized by respected associations, leading companies, standards bodies, scholars, and industry experts, the PLUS Coalition exists for the benefit of all communities involved in creating, distributing, using, and preserving images. Spanning more than thirty countries, these diverse stakeholders have collaborated to develop PLUS, a system of standards that makes it easier to communicate, understand, and manage image rights in all countries. The PLUS Coalition exists at the crossroads between technology, commerce, the arts, preservation, and education."

CC offers licensing solutions for creators to share their works for use by others while PLUS strives to standardize commercial licenses written for specific users and customized uses. CC licenses are attractively simple, offering a handful of choices for licensing your work—require attribution adjacent to any use, require that any derivative creation carries the same license as your original, restrict the creation of derivatives altogether, and restrict any commercial use of the image. These licenses—especially those requiring attribution and restricted commercial use—can be applied to images we create and distribute through social media outlets, blogs, or Web sites allowing us a way to utilize these new venues as marketing outlets while maintaining certain legal protection for our work. Some of you may have no interest in your work being shared in anyway and prefer to maintain the "all rights reserved" default that the copyright law gives you. This is your choice, but I suggest that opening up some uses of your work will hold more benefits for you and your business than being overly restrictive.

The flaw in the CC licensing model for us is that these licenses are assigning specific rights to everyone—the world becomes the licensee. This is where PLUS steps in providing a system to generate licenses for a specific client, which is a critical distinction when we are extending commercial uses to a paying customer. Where CC accomplishes much in the non-commercial space, PLUS is critical to our survival in the arena in which we generate income.

The PLUS glossary defines a universal language for licensing and a universal format for writing licenses. The next step for PLUS is the launch of a searchable image registry combined with a license generator and embeddable PLUS ID that will travel with our digital files. These codes will contain all copyright, contact, and licensing information for a particular image. Additionally, PLUS has created a searchable image registry combined with a license generator. This searchable image registry helps us and it also protects the investments of our commissioning assignment clients by, at long last, making the licensing terms of any particular image accessible from anywhere. No more questions about who has the rights to use a particular image.

Not only does such a registry forestall problems caused by changes to copyright law, such as the expected "orphan works" legislation, it sets up the infrastructure necessary for individual visual artists to finally benefit from small online uses of their works. As iTunes has demonstrated loud and clear: when an easy and affordable way to license the use of creative works is available, people will use it. In the absence of one, users will work around the established system to get what they want, as was the case with Napster.

Consumer use of our work, however, is only part of the pie. Online platforms, such as Facebook, YouTube, or Yahoo, offer places for consumers to share information for free while generating income through advertising placed on those pages. Google AdSense goes a step further placing relevant ads on individual Web sites and blogs, sharing the advertising revenue with the blog or site owner. If collectively our photographs are in a searchable registry, the infrastructure exists for us to receive small royalties when these new small and large online publishers use our content. We need to utilize this registry to leverage our stake in these growing commercial spaces.

The value of such an image database cannot be stressed enough, but we need to recognize that the initial burden will be on each of us as individual artists to use the system. The Internet makes distribution of photographs easy. We need to make

licensing easy. In these licensing infrastructures lies the survival of our industry. To be successful we must embrace this new and changing environment. With our full participation there is enormous opportunity.

Chapter 7

FUTURE PROSPECTS

I don't believe there ever has been one answer for how to build a successful career as a photographer, but the variations today seem endless. The ease of information creation, consumption, and distribution that new technology provides is the significant game changer of our industry. Photographers who understand and utilize this transformation are the individuals who will successfully redefine their role as professionals and find a market for their talents.

The pace of change for our businesses is not going to slow anytime soon—it seems only to accelerate, particularly in the area of the shift from print to online publishing. Ken Auletta, in his book *Googled, The End of the World as We Know It*, chronicles the history of Google as a company and, at the same time, tells the story of the recent disruptive changes in traditional media and advertising. As creators, our livelihoods are linked to and greatly affected by these evolving circumstances. Discussing how new media is defined, Auletta writes, "The belief embraced by too many television (and movie) executives that they are in the content business—and most digital companies are not—is not just smug but stupid. Content is anything that holds a consumer's attention." He goes on to point out the continual increases in the audiences on Facebook, YouTube, and Twitter, then citing a 2009 Nielsen report he writes, "Eighteen to twenty-four-year-olds now spend the same amount of time—five hours a day—watching Internet video as American adults spend watching TV."[33]

The eyeballs of consumers are moving online, where the work of many independent photographers can be found, and the advertisers

are following. The tracking of consumer interest that online advertising provides the advertiser is powerful. Buyers can now learn specific information about who responded to their advertising placements. And, as Auletta points out, "Marketing thus becomes less opaque, robbing ad agencies and sellers of their ability to sell what Mel Karmazin called 'the sizzle' . . . This transparency and the additional supply of media outlets, as well as a suspicion that advertising and media agencies had not sufficiently adjusted their fees downward, shifted leverage to the true buyer, the client."[34]

Information is now easy to create, distribute, and consume.

This truth:

- Changes how our clients do business.
- Changes what our clients need from us.
- Changes our access to potential clients.
- Democratizes the creation and distribution of photography.
- Increases the ease by which works can be used without permission.

If we acknowledge and embrace the opportunities presented by these changes, we can individually build futures as photographers. We need to throw out business practices that are at odds with this changed economy while simultaneously ramping up the practices that are critical to sustainably monetizing our work. The real challenge is distinguishing the difference and for each of us, the answers may vary.

For me, I am ready to loosen up on absolute control over the distribution of my work. If I share my images for non-commercial uses, I believe I will increase my visibility as an artist. The key will be making sure all uses carry my attribution and when a use is online that it links back to my Web site. I see real value in making my original commissioning clients true creative partners offering flexible licensing terms and seeking mutual attribution of our efforts. I want to build a business that realizes my belief that the still image has extraordinary value as a communication tool, and, for me, that means both creating work and helping other image-makers strengthen their photography and businesses.

Sean Kernan shares his thoughts.

After years in the business and the profession of photography, making a modest success of it, I found, as many of us have, that that business is morphing in some way I can't discern. So what to do about that? I think the worst thing I could do is to insist that the only 'good outcome' would be a return to its previous shape. In a very real sense I began photographing from this impulse to see and explore, and I made my way by surfing whatever energies I found . . . which included magazines, making images for advertising, doing catalogs, working for corporate clients, even coming up with an idea that CBS made into a Movie of the Week, unlikely as that seemed.

But I always kept in touch with my original impulse—or perhaps it kept insisting on itself—and I used anything at hand to explore it. So I began writing and playing with sound and video. I also kept expanding my teaching, at least partly as a way of learning.

At this point I find myself involved with working on several film ideas, working with a group of dance/performance people, working with a friend to illustrate a poem . . . all of which lie outside of photography proper. I feel very insecure in all of these endeavors, but I know that that is the sign that something might happen, something unlike what I've already done.

Such as what? I think that is probably only a minor point. When I first began teaching I had a wonderful Japanese student who said to me, 'You teach photography as a Way.' I didn't really know what she meant at the time, but she was right. Photography was a Way for me. And is.

I am very involved in the technical and business aspects of photography, and I have done well enough with it all, but I think that part of the reason that I have is that I remember that it is a Way. Not a way to a destination but a way to keep moving, toward everything. I've done well by leaving things to evolve, and I hope I'm not fool enough to change that.

Richard Kelly discusses his future.

I see my business and my photography changing in a number of ways. My personal projects are merging into multimedia channels similar to larger media platforms. Tools are now available allowing me, as an individual artist, to produce like the big guys. Rather than hoping and waiting for exhibitions or books, as I was doing in the analog world, I can build the publishing platform for my work, no more waiting. I see these projects having sponsors, advertising, and even members. This is the Googlization of personal art projects.

The need to diversify my income has led me to doing small business consultations. I am using my skills to assist businesses in defining their unique strategic vision. This is proving to be a valuable and marketable asset, my problem solving abilities and expertise in social media are put to use as my clients struggle with integrating new communication platforms into their businesses.

I believe there are a number of changes taking place that are going to positively impact the ability of photographers to have their images found online and then be able to complete an efficient licensing transaction. This will allow me, as a photographer, to produce work for niche markets that match my interests.

My future prospects will include multiple income streams flowing from diverse and targeted sources. My role will be more publisher and producer than assignment photographer.

The photographers profiled below are building varied futures in this new economy. There is no one right answer for how to succeed as a professional photographer today—the common thread in all these stories is that these individuals are pursuing genuine interests in their quests for a unique and sustainable career.

Jenna Close and Jon Held founded P2 Photography in 2007, specializing in photography for the alternative energy market. This

personal passion for sustainable environmental solutions lead them to focus their marketing and sales efforts on this niche and growing industry. They take on commissioned assignments, as well as market their stock imagery through "Green Stock Media" a small agency licensing images featuring environmental and sustainability subjects.

Jenna and Jon took an unprecedented approach when launching this very targeted marketing effort by purchasing booth space at trade shows for the alternative energy industry. The cost related to participating in a trade show can be significant, especially for a small photo business, and these events consume nearly half of P2's annual marketing budget. It is no surprise that they were the only photographers at these shows—Jenna and Jon in a huge room full of potential clients! It paid off. They made connections, followed up, built relationships, and the work followed.

By combining their passion for ecology and photography, they are building a growing loyal client base. Take a look at their work, *www.p2photography.net.*

Blake Discher is a Detroit-based photographer specializing in photographs of people for editorial, corporate and advertising use. Blake is a tech guy, an early adopter of digital photography and one of the first photographers in his area promoting his business online. Uncharacteristically, he is also a master salesman and the combination of being tech savvy and personable has been the key to his success.

Blake is a master at search engine optimization (SEO) making sure that a Google search for "Detroit photographer" consistently returns his name at the top of the list. Once found, Blake makes it easy to work with him by always focusing on solutions he can provide the client and following each project up with exceptional service.

In addition to being a photographer, Blake educates and consults colleagues on SEO and negotiating skills offering

in-person, video, and online training. These supplements to his work as a photographer keep him involved in the industry he loves and fully utilize his areas of expertise.

Take a look at Blake's photography site at *www.fireflystudios.com*—take special note of his studio mission statement. Go to *www.go-seo.com* to learn about his SEO consulting business and read his blog *www.groozi.com* on negotiating and Web marketing.

Lucas Doran Cosgrove is a photographer and graphic designer based in Kansas City, Missouri. He specializes in conceptual people photography with a hard-edged surreal feel. In addition to serving clients through his photography and design services, Lucas has launched the "Red X Studio and Incubator" project offering affordable office and studio space to other freelance artists.

He purchased the property adjacent to the building housing his 5000 square foot studio. He opened up a passage between the two buildings and created one large working environment. Lucas will offer five to seven desks available for rent to Web developers, artist reps, copyrighters, producers, photographers, designers, or others working as creative professionals.

The isolation common when working as an independent freelancer inspired Lucas to create what he hopes will become a creative incubator. His self-stated mission is to create a "fun, competitive, inspirational, and functional space" while simultaneously sharing the cost of the support services any small business needs.

Check out Lucas' portfolio site here *www.lucasdoran.com* and look for news about the "Red X" project on his blog *www.lucasdoran.com/blog*.

Ken Hawkins is a photojournalist. He traveled the world for over 20 years, and his photographs have appeared in many publications including *Time*, *Fortune*, *Money*, and *Wired*. Ken's graphic

sensibility and dramatic use of light make his work a natural fit in the annual report and corporate markets working for clients such as FedEx and Coca-Cola.

After relocating to Portland, Oregon, from Atlanta, Ken launched his online gallery business, 52selects.com, exclusively featuring photojournalism and documentary photography. Ken functions as the gallery curator utilizing his long-standing relationships with fellow photojournalists to find the artists he now represents at 52selects.com. His passion for photojournalism inspired his business model, which offers amazing work at reasonable prices, allowing Ken to promote fellow photographers and meaningful photography. Ken achieves this by offering un-editioned prints that he produces in-house. The prints are then approved and signed by the artist and shipped to the collector. He and his photographers split the sale 50/50.

Ampersand in Portland, Oregon, is Ken's brick and mortar gallery partner. 52selects.com offers prints for exhibition and provides the gallery a commission on any sales. Ken hopes to establish many more gallery partnerships like this offering small photo galleries another resource for quality imagery to exhibit and providing another place to promote his photographers.

Ken promotes his gallery by selecting an image per week, hence "52 selects," that is highlighted on the Web site, partner gallery, and social media outlets. Ken offers exclusive discounts to his newsletter subscribers and Facebook fans, building himself a loyal following of current and potential customers.

View Ken's own work at *www.kenhawkins.com* and take a look at his gallery by going to *www.52selects.com*.

Judy Herrmann and Mike Starke own Herrmann + Starke in Ellicott City, Maryland. For over twenty years, they have offered distinctive imagery of people, products, and places for commercial and editorial use. They license their work as stock through Corbis and work client direct on a variety of commissioned assignments. View their work at *www.HSstudio.com*.

Their business plan has consistently emphasized the sound business principle of diversification. As early adopters of digital photography, Judy and Mike started sharing their delight in this new technology with fellow photographers in 1995 through lecturing and holding workshops. The combination of being practitioners and teachers in the pursuit of exquisite craft and sound business skills has been part of their business model since.

In 2007, Judy and Mike established an employee run retail portrait division called Cookie Portraits, *www.CookiePortraits.com*. The employee photographer creates the portraits, manages the retail studio, establishes a marketing budget, executes a sales strategy, and tracks expenses. When there is a specific level of profit, the employee enjoys profit sharing above an already guaranteed salary.

Judy's skills as a strategic thinker have recently led to a new opportunity, offering a different kind of consultation to photographers. At these sessions, she doesn't begin by viewing photographs, but rather by discussing the kind of business the photographer wants to build and then working out steps to help make the goal a reality. Her consulting success has opened another marketable skill, an opportunity to further expand the offerings of the studio. Learn more about Judy's consultation services at *2goodthings.com*.

Barbara Karant is an established architectural photographer nationally known for her exquisite images of the built environment. She exhibits her work, has won numerous photography awards, and is included in many permanent collections including the Art Institute of Chicago and the Avon Collection.

In 1997, Barbara adopted a retired racing greyhound named Easton and soon became an active volunteer for the nonprofit rescue group "Greyhounds Only." Barbara started photographing Greyhounds as a way to benefit this rescue effort, producing products with her images to brand the group and promote their cause. The work of capturing the beauty, grace, and quirky

qualities of this breed challenged Barbara's meticulous nature. This subject didn't hold the pose like a building, but she persevered and produced a unique and bold series of images that was published in the book *Greyhounds* in 2008. The success of this book led to a contract with the publisher Simon & Schuster to produce another dog-themed book, *Small Dog, Big Dog*, released in 2010.

Barbara's affinity and skill for photographing our four-legged friends has sparked a new business venture, Karant Canines, a retail dog portrait studio. Her architectural photography work remains an important part of her business, but this new direction affords Barbara diversification that she feels is critical to her career as an independent businessperson and artist.

Go to *www.karant.com* to view Barbara's architectural photographs; see the greyhound book at *www.greyhoundsthebook. com*, and learn more about her new business at *www.karantcanines.com*.

Kim Kauffman lives in Lansing, Michigan, where she owns a full service studio and location photography business serving a wide variety of clients from manufacturing to healthcare. Kim transitioned to digital photography and Photoshop like a fish to water, using these new tools to push and expand her vision of complex multiple image illustrations. The style of her personal work is applied beautifully to commercial applications and Kim highlights this in a portfolio that she calls "Duets," which can be seen at *www.kimkauffman.com*.

Kim created a series of botanically themed collages by scanning items grown in her backyard garden—she calls this series "Florilegium." The success of this work on a local level led her, in 2001, to focus her marketing energy and budget on promoting fine art images. She carefully researched galleries, both specializing in botanical themed art and photography, to determine the market for her work. She then established print prices that ensured a healthy profit after the production costs of producing the images. She

actively pursued exhibition opportunities, attended portfolio review conferences like Fotofest in Houston, and marketed directly to her targeted list of galleries.

Kim still serves commercial clients, but the sale of her art prints now represents over 50 percent of her income. Eight galleries around the country represent her work, a boutique hotel in North Carolina purchased a series for display throughout their property and her images are included in many corporate and museum collections. Learn more at *www.synecdochestudio.com*.

Gail Mooney, together with her partner Tom Kelly, own Kelly Mooney Productions offering still and video services to a wide variety of editorial and commercial clients. Gail's roots are in editorial work, traveling extensively for such clients as *Travel + Leisure*, *Smithsonian*, *Time/Life*, and *National Geographic*.

Ten years ago, before it became fashionable, Gail started working with video. Her passion for photography has always been connected to storytelling and video was a natural progression for her work. She and Tom now offer a full range of video production services, as well as licensing stock footage through Corbis and Thought Equity Motion. The Kelly Mooney Productions Web site can be found at *www.kellymooney.com*.

Gail has embraced social media as a way to tell her own story, the adventures of a still photographer moving into motion. On her blog, "Journeys of a Hybrid," she candidly discusses the technical, business, and aesthetic challenges of working in both worlds. Follow Gail at *www.kellymooneyminutes.wordpress.com*.

Gail and her daughter, Erin, embarked on a world trip in May 2010 with the objective of filming seven stories on seven continents. The stories will highlight the works of seven individuals who are doing extraordinary things to make the lives around them better. Ultimately this work will be available as online video shorts and a full-length documentary film. Gail and Erin's trip is chronicled at *www.openingoureyes.wordpress.com*.

Sean Williams is a Chicago-based photographer creating high production imagery that is marvelously lush and cinematic. His distinctive style landed him, after only four years as a commercial photographer, a feature profile in *Communication Arts* magazine.

Sean has a master of fine arts in creative writing but moved to photography to fulfill his artistic drive. His extremely complicated productions, set and prop building, models, assistants, lighting, locations, and much more, are a challenge he thrives on. Working out of a 3,000-square-foot studio, which Sean considers more of a creative workshop, he employs a collaborative work process to produce, piece by piece, his extraordinary images.

To market his work, Sean shares on his Web site behind-the-scenes videos of actual productions, which show prospective clients the elaborate nature of the set-ups, combined with his meticulous attention to detail. The result is a magnificent promotion. Sean clearly indicates in these videos that he is the producer, and thus positions himself to negotiate the large fees and expensive budgets the work demands. View his work at *www.seanwill.com.*

THE WELL ROUNDED PHOTOGRAPHER

"At our best and most fortunate we make pictures because of what stands in front of the camera, to honor what is greater and more interesting than we are. We never accomplish this perfectly, though in return we are given something perfect—a sense of inclusion. Our subject thus redefines us and is part of the biography by which we want to be known."[35]

—Robert Adams

The importance of pursuing your own photographic work is a major theme of this book. I believe it to be a necessity, at the root of all that we do. There are simply too many photographs and too many photographers out there to compete unless you offer the market-place a genuine vision. Professional photography is a difficult pursuit and if you are not driven to create your own work, there is little reason to make the significant effort that running a business in this industry will require. The harshness of this may sting a bit, but an honest examination of why you choose to pursue photography is important. The answer will chart your course.

The photographs shown here are selections from significant bodies of work by Sean Kernan, Richard Kelly, and myself. The images and accompanying artist statements taken together symbolize our commitment to the pursuit of our personal visions.

Sean Kernan

SECRET BOOKS

The series I call The Secret Books began in a moment of emptiness and boredom.

I was hanging around my studio with nothing much to do, thinking about cleaning up in a desultory way. There was an old book lying out on a table. I went to put it away, but instead I just opened it and gazed. I looked at the way the sharp metal type cut into the paper, at the foxing in the margins. I smelled its slight odor of papery rot, caught Latin words here and there, and made out that they said something about the spirit and devotion. I stood there for the longest time.

On an impulse, I went to the closet where I keep a compost heap of props and got four black Japanese river stones and set them out carefully in a line across the pages of the book. And suddenly it looked to me like . . . a poem. It didn't narrate or argue but just placed a few simple things before you and invited you to complete it. This book with its stones was a pure image, the kind that can move from one mind to another and root there in some mysterious panspermic process. Joining things that didn't logically go together—Latin meditations and Japanese rivers, black stones and creamy paper—broke apart some notion of what these things should say and set my imagination free to work. I had always wanted my photography to do this.

I took a picture of this poem. And that was the beginning of these books.

The project went on for a few years. Each time I did another one I'd get this shot of energy, and it would propel me forward. I

walked around with the image of an open book in my head all the time, and I'd keep seeing things that could go on it. A lot of those things didn't work, but the ones that did fired me forward again. Over time I must have done about 80 or 90 photographs. When it came time to think about making a book of them, the project shifted from a group of single images to a single sequence that flowed from one picture to the next. In the end there were several favorite photos left over. I kept trying to find places for them, but each time the project just popped them out again.

Working on the book, I couldn't decide if it needed the armature of a text or what that text might be and how it might work to unite the whole. Then a designer friend, Lana Rigsby, saw the pictures and said they reminded her of Jorge Luis Borges.

Of course!

I looked at Borges in the light of my pictures, and at once the connection was clear, particularly when he wrote about books. In the story *The Book of Sand*, a stranger seems relieved to sell the narrator a book. This book, the narrator discovers, can never be opened to the same page twice. Its contents shift and slide within the pages and defy the expectation that a book should contain and fix what is in it. The narrator becomes obsessed. He tries to plumb the book and find its rationale, its organizing principle, but he cannot. It has every possibility in the cosmos spread across its ever-changing pages, shows him glimpses of all creation. And suddenly he grasps what the book is telling him—that, contrary to what he has always believed, there is no possibility at all of knowing the world, not even his own immediate world, through intellection. In fear, he abandons the book on an anonymous shelf in the depths of the national library, from where it continues to haunt him. The narrator's mundane act of buying a book and opening it sends the reader spiraling into his own series of haunting considerations.

This was perfect. I kept combing through Borges' work until the whole thing fell naturally together.

The Secret Books doesn't attempt to illustrate Borges, and it doesn't really aspire to be a collaboration—as an artist I couldn't

hold his coat. I simply found some instances in which he spoke directly about books and put them with my images of books in a kind of dialogue.

I love pictures that you simply can't set out to take. Here was a whole project of such pictures. From the beginning it had its own life and integrity, and I simply allowed it to carry me along, past everything I had done to that point. It has happened a few other times, and each time I am literally another person at the end of it.

I've come to think that empty presence is the state an artist needs to be in when a great project hits. I'd suspected this for some time, that art begins in presence and is followed by thinking. This project solidified that forever.

Book with Stones

Book with Shapes

Book Burning Hand

Book and Hand with Water

Eclipse Book

Book in Room

Planets Book

Book with Mirror

Book with Skull

Written Book

Richard Kelly

ARTISTS AND SCIENTISTS

The Artists and Scientists project started serendipitously.

I was on assignment photographing a medical research lab at the University of Pittsburgh, spending a fair amount of time observing and interviewing my subjects while they continued their experiments. Over a period of days, I noticed that the scientists were using problem solving techniques similar to my artist friends. One thing that struck me was the number of failures that were part of the creative process. Another was the small discovery that led nowhere but was treated positively as part of the big picture.

Inspired by the work of photographer August Sander, I continued photographing the very formal portraits of scientists in their work environments. In a parallel series, I was photographing artists, including painters, writers, and musicians. This is a group of individuals who I have regular access to, and to prepare myself for the photo sessions I listened to their music, looked at their paintings or read their words. By preparing, I strive to figure out the impulse, the intent of the process that takes an idea to personal expression.

I am fascinated by the creative process that begins with simple curiosity or a question posed. I came to realize that this process is very similar for artists and scientists. This realization led me, in 2003, to combining these two portrait series into one. The "Artists and Scientists" project was officially born, and I am now in the process of researching and asking the "best in their class" subjects to be a part of the series.

While exhibiting this work in progress, I met a workforce development researcher and her interest in my project led to her suggestion that I create a multimedia tool that would allow searches by middle school students, the age when many students find their direction in life.

My new goal for this project is to create a multimedia production utilizing the photographs, biographical text, and audio. I will be using the vast data available through the Internet to create a virtual portal about the creative process of artists and scientists.

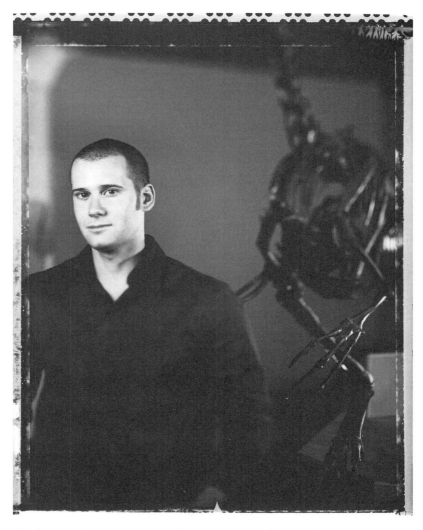

Matt Lamanna, Paleontologist at the Carnegie Museum of Natural History

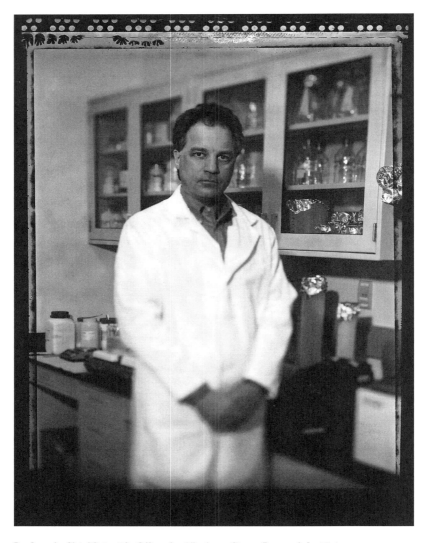

Dr. Joseph, Chief Scientific Officer for Allegheny Singer Research Institute

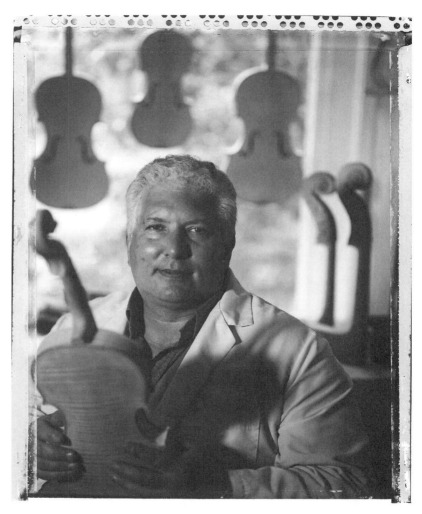

Philip Injeian, Artist & Scientist, Master Violinmaker

Jason Guilisano, Executive Chef/Owner, The Green Cup Restaurant, Vermont

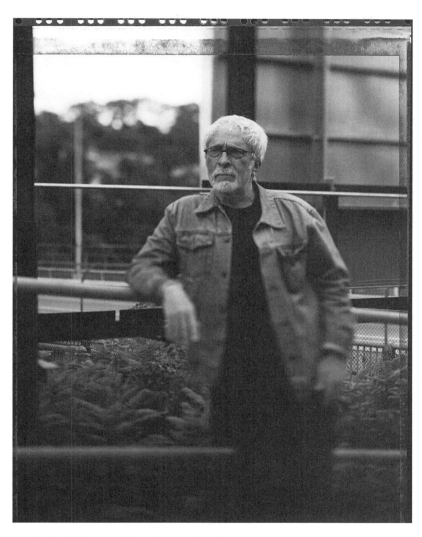

Lee Gutkind, Writer and Editor, Creative Non Fiction

Sharon Klay, Winemaker, Christian Klay Winery

Bill Deasey, Singer & Songwriter

Duane Michals, Photographer

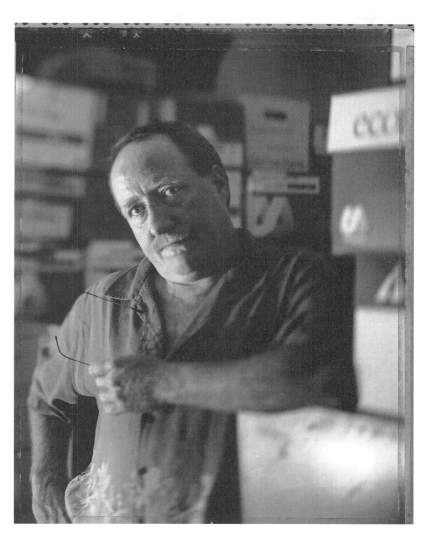

Bill Moushey, Journalist and Director of Innocence Institute at Point Park University

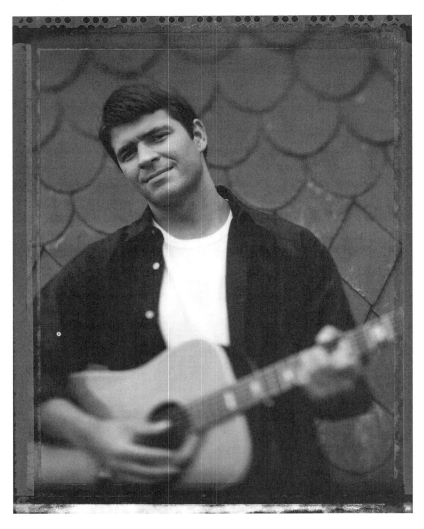

Dr. Todd Blodgett, Radiologist at UPMC and a Singer Songwriter

Susan Carr

PERSONAL SPACES: DETAILS OF AMERICAN HOMES

In early 2000 I began photographing the homes of people who have lived in the same place for forty years or more.

The impetus for this work was a visit to my Aunt's childhood home in Jackson, Mississippi. Sitting in Mildred's dining room in a home she has lived in for forty-nine years, I realized that this kind of personal space was fast becoming one of our few remaining unique environments. Jackson, like so many other American cities, is plagued with urban sprawl that has deadened the city center and homogenized the surrounding landscape. In a country that prides itself on individualism, it is now possible to buy the same cup of coffee, the same clothes, and the same meal from one coast to the other.

Shortly after my visit to Jackson, I set out to photograph the details of American homes. At the beginning I thought this project would be about the structures as much as the contents, but once into the project I realized I was more interested in creating still-life images of the things people collect and display to be part of their everyday lives. Witold Rybczynski, in *Looking Around, A Journey Through Architecture*, observes, "The embellishment and arrangement of a home are a graphic (and sometimes symbolic) representation of public and private cultural attitudes toward domesticity and family life."[36] The objects we surround ourselves with speak to who we are.

The self-imposed boundary of working in homes with forty years or more of residency by the same person was set for practical

reasons. Any longer and the amount of subject matter available to me became too limited, any shorter and the passage of time didn't seem sufficiently long enough. I felt a certain number of years living in one place was necessary for a sense of presence and permanence to take hold. Additionally, the limited number of people who reach the forty-year marker in one home places my subjects, to my way of thinking, in an exalted class.

Five years into this project I moved to a new city leaving behind my home, a small cape cod style house, of over fourteen years. The fresh start relocating offers can be exhilarating, yet leaving a home is a challenging event in one's life. I still miss the place, not the house specifically, but the place I built by being there. The collective memory of my things in particular spots, in varied seasons, with different people and pets, meals, work, and relaxation. It all merges into one overwhelming feeling that resonates as my place, my home. This move was a realization that I will likely never reach the mark of time in one place that I used to structure this project. My belief in the power of the subjects in these photographs, the places, continues to grow.

In our culture we celebrate moving on, out, and up. Bigger and newer are frequently synonymous with better. I have a great respect for people who have not followed this path, but instead have chosen to stay in one place. The decision for some is very calculated and for others more ambiguous, but a strong sense of place exists in all of their homes and in their lives.

I treasure the moments I have spent in these homes and with the owners. Together, we have created our own small intimate history, but the photographs move beyond that experience to uncover a rich labyrinth of years defining the power of place, the significance of home.

Kitchen, Emma and Bill Bouldin Home, Philadelphia, Pennsylvania, 2003

Lincoln Relief, Mervin and Jean Jackson Home, Leesburg, Virginia, 2001

Family Room, Myrtle Troutt Home, Ostsego, Michigan, 2000

Kitchen, Private Residence, Kalamazoo, Michigan, 2000

View into Kitchen, Norman and Cora Fournier Home, San Antonio, Texas, 2005

Kitchen, Ruth Mendez Home, New York, New York, 2000

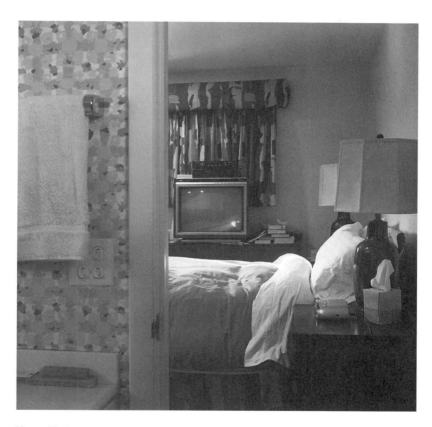

View of Bedroom, Lawrence and Annette Grubman Home, Skokie, Illinois, 2009

Bedroom, Helen Jackson Home, Leesburg, Virginia, 2001

Dresser, Joan Stall Home, Reisterstown, Maryland, 2001

Basement, Suzanne Shepherd Home, Kalamazoo, Michigan, 2000

Chapter 8

THE NEW PROFESSIONAL PHOTOGRAPHER

The well-rounded photographer is an artist who exhibits excellence in business, craft, and creativity. This combination is the distinguishing characteristic of a professional. These three components are distinct, essential, and interdependent to the success of today's independent working photographer.

Talent can exist and fail to provide you income in the absence of sound business practices. You can have an innovative vision, but if your craft is substandard, the vision will not be expressed to its full potential. Conversely, a successful business strategy that does not deliver an excellent product will fail in spite of the planning. Acknowledging this recipe for success is more critical today than ever before.

In the not too distant past it was possible for a photographer with good business skills and technical prowess to make a living producing mediocre images. Well, in today's marketplace the mediocre images are available for free or nearly free or are created in-house by an intern or assistant. For a professional working today, producing average work will simply not cut it. It's a common refrain from the professional photography community that our clients will not pay for high quality anymore, that they rely instead on images that are "good enough." If you only produce "good enough," you are replaceable. You must make your images extraordinary and personal.

The "eccentric" photographer, one who acted like an ass to clients and was sloppy on the business side but created visionary work could at one time also get consistent work, perhaps even thrive. No more. There are simply too many options available for

clients who need photography to put up with bad behavior or sloppy business. Unprofessional behavior offends people and conducting business without contracts creates the potential for legal troubles. Both are liabilities to our clients.

The photographer who mastered a special technique was, at one time, in demand. Now there are too many tools readily available for nearly every technique used in image creation, from alternative processes to the latest in digital technology. Technique alone cannot sustain a photography business.

Pursuing photography for the love of making images while doing other work to put food on the table or kibble in the dog bowl is a worthy choice. However, if your goal is a successful career as a photographer, it is imperative that attention be given to business, craft, and creativity. The following chapters outline considerations and resources for developing skills in these three critical professional areas.

Chapter 9

BUSINESS

There are few endeavors more challenging than successfully running a small business. Most professional photographers are one, maybe two, person shops, meeting the demands and diversity of tasks before us on a daily basis can be arduous. The list of concerns a photographer must address under the category of business range from making sure taxes are properly filed and bills are paid, to estimating projects and hiring assistants, to developing a marketing strategy and engaging in sales. As outlined in previous chapters, this is a volatile time for our profession as our major client base of publishers and media companies is scrambling to define its role in an online economy and, consequently, so are we. These disruptions are changing who our future clients will be and simultaneously providing us new tools to manage and market our work. This turmoil, however, does not alter the necessity for sound business practices. In fact, these basics are more important than ever.

Knowledge of Copyright and Licensing

My feelings about the importance of copyright and licensing for photographers are, I am sure, abundantly clear by now. Whether you are working full time, part time, as an assistant, an employee, or making images just for the love of it, it is likely you want your photographs to be seen. Photographer and writer Robert Adams states this clearly in his book *Why People Photograph*.

"Artists sometimes claim that they work without thought of an audience—that they make pictures just for themselves. We are not deceived. The only reward worth that much effort is a response,

Business Musts

- **Knowledge of copyright and licensing**

 You cannot sell something you do not understand. You must understand how these things work to accurately determine your fees.

- **Knowledge of model and property releases, privacy rights, and trademark**

 This is critical to protect both you and your clients.

- **A methodology for determining your price**

 Do not use a pricing dartboard. Follow the steps and your prices will have concrete meaning.

- **Register your copyrights and submit images to an online image registry**

 Make this part of your regular image production workflow. It protects your assets and your client's investments.

- **Business management**

 Photography-specific business forms—estimate, assignment confirmation, change order, delivery memo, and invoice.

 Professional services team—accountant, insurance agent, estate planner, lawyer.

- **Career planning**

 This is a critical and ongoing process.

- **Marketing plan and sales strategy**

 Without a plan you are wasting money and without the skills to sell your services you will not succeed.

and if no one pays attention, or if the artist cannot live on hope, then he or she is lost."[37] Accepting that we all create with intent to share or sell our images, it is then critical to understand what rights we have as the copyright holders of our work.

The ability to professionally license the use of your images and to understand when certain uses are "fair" and do not require a license is indispensable in today's marketplace. I covered these topics extensively in chapters 5 and 6, however, I want to stress again the need for clarity in how copyright, licensing and pricing are hinged. William Patry writes, "Consumers are king—not control, not copyright, and not content. Without consumers, copyrights and content have no economic value. Copyright is not fairy dust, vesting everything it touches with magical economic value. Rather, economic value is derived from buyers' willingness to pay for a product or service"[38]; in other words, we need customers or we cannot monetize the rights we have to our work. I remember clearly the outrage of many photographers when, in 2002, newly hired ASMP Executive Director Eugene Mopsik wrote, "The value of a copyright is similar to the value of your house. No matter how much it appreciates in the market, the only ways to get the cash out of your house are to sell, rent, or borrow. Simple ownership and price appreciation create a sense of security, but not a change in your cash position." Many felt Mopsik was saying copyright was not important when he was actually stating the reality of business, that the market and not the copyrights determines the economic value of our images. The copyright law gives us the monopoly to exploit the use of our images, but the actual value of that use is based on the dollar amount paid by our customers. Understanding this distinction helps us as we navigate the business of pricing and licensing work. What the market will bear is dominant and our job is to provide an uncommon and exceptional product and/or service so that we can garner the fees necessary to make a profit.

Knowledge of Model and Property Releases, Privacy Rights and Trademark

Your ability to license a particular image for a specified use may be contingent on securing the proper releases. The ASMP tutorial on releases states, "A release is a written agreement between you and the person you are photographing, or the person who owns the property you are photographing. The purpose of the release is to protect you from any future lawsuits the person might file for claims such as defamation and invasion of privacy." Releases are typically required when the use of an image is commercial, for purposes of trade or advertising. However, editorial use generally does not necessitate a release and releases are generally not necessary for personal uses, such as: wedding albums, personal portraits, or display art. The ASMP outlines this norm: ". . . the courts have long held that news reporting and social, political, and economic commentary—the things the First Amendment was designed to protect—are more valuable to society than an individual's right to be left alone. Therefore, images that are part of the public colloquy about events have usually been exempt from privacy lawsuits. In contrast, the courts have generally held that making money is distinctly less valuable to society than the right to be let alone."

Privacy rights in the United States, unlike copyrights, are regulated state by state and due to the Internet our work is rarely published in only one region, so we must defer to the most conservative interpretation of these laws. Additionally, some states have extended "publicity rights" to celebrities and their heirs allowing control over the commercial use of their likeness.

The four categories of invasion of privacy are:

- Intrusion
- Public Disclosure of Private Facts
- False Light
- Appropriation

A person must be in a situation where they can claim a "reasonable expectation of privacy" to exert their right to privacy. Attending a sports event or rally, walking down the street or sitting in a public park are all examples where an individual cannot claim an expectation of privacy.

Nancy Wolff explains the importance of the invasion of privacy through appropriation as it relates to a commercial use of photography. "This involves the unauthorized use of a person's photograph, name, likeness or voice for commercial purposes, which damages the person's dignity, interests, and peace of mind."[39] Therefore, even when no privacy expectation can be exerted like the sports event example above, if the use of a person's likeness can be deemed detrimental to them, the use can be ruled a privacy violation. This is why obtaining a model release from a photographic subject is critical for any commercial use of the image.

Property does not hold rights as an individual does and information on the necessity of releases when personal property is the subject matter of a photograph is murky at best. The cautious approach is to acquire a property release anytime the use of the image is commercial in nature. Remember, the owner of the property, who is not necessarily the client, must sign the release.

A trademark is a unique mark that indicates the source of a given product. Examples of objects that hold trademark status include a Coca-Cola bottle, McDonald's golden arches, the NBC peacock design, and Apple Computer's apple. Trademarks that are registered at the Federal level may indicate this registration by placing the symbol ® adjacent to the mark. The symbol ™ indicates that the mark is being used as a trademark but has not been registered. Registration is not necessary for a trademark to be valid. You can photograph a trademarked object legally. The question, however, is how the resulting image can then legally be used or licensed, with commercial use being the primary area for caution and legal advice.

Richard started his career assisting in the fashion photography world of Miami where professional models are the norm and releases are a regular part of the business. Models are frequently

under contract with a modeling agency and can only sign releases executed or approved by their agent granting the client very specific use of their likeness. Just as we want and need to protect the copyrights to our photographs, these models need to protect the commercial use of their likeness. Too many artists complain that models will not sign generic releases granting the photographer unrestricted rights to use the photographs created on an assignment. Professional models are likely under contract with an agent and legally cannot sign your release, and, more importantly, it is necessary for us to make fair requests of the people we photograph. Richard states, "I ask my models to sign a release that limits the use of the image to the specific client's needs and the ability for me to use the work in my portfolio. I ask for what I need. I make a reasonable request and I get a reasonable result." This is an excellent practice when working with professional or non-professional talent and can also be applied to the need for a property release. If you have an opportunity to re-license an image, you can always return to the model or property owner and seek another specific release in exchange for additional compensation. Professionalism is warranted in all our business relationships, including the talent and property owners participating in our ability to create the image.

Remember that model and property releases are needed for images posted on your own Web site. You are promoting your business making this a commercial use. If you are planning to put a Creative Commons (CC) license on an image with a person, you must have an unrestricted release from that person or, at least, put the no commercial use restriction on the CC license. And be careful distributing work on social media and photo sharing sites. Copyright registration and necessary unrestricted releases are recommended before this kind of image distribution is utilized.

The American Society of Media Photographers (ASMP) has detailed information on releases and sample forms at *www.asmp.org/releases*.

A Methodology for Determining Your Price

The need to understand how to properly determine your price cannot be emphasized enough. You cannot sell your services without a true comprehension of how you determined those fees. The steps to determining your price are covered in detail in chapter 6. Additionally, take a look at this real world scenario that illustrates the need for pricing on concrete terms.

The marketing assistant for a ceiling fan manufacturer called me for a quote. She needed photographs of a Chicago restaurant interior to be used in an upcoming brochure and on their Web site. She had located our business by searching on Google for a Chicago architectural photographer. She liked our work, especially the lighting of the interior spaces.

Her photography list included images with and without people, showing various angles of the space making sure to highlight their fans. My contact did indicate they had no budget for professional models, but she would not share her overall budget with me. I was cautiously optimistic—she was thorough, indicating she hired photographers regularly, she had a deadline, and she appeared to want my expertise.

I went to the restaurant Web site to get an idea of what we would be facing. The location has cathedral ceilings with skylights on either side of the fan. The décor is dark with dramatic lighting. The space would be a challenge to light properly while keeping the mood and also showing off the featured ceiling fan.

I put together the estimate making sure to cover all the details necessary to give this client the same quality of work featured on our Web site. The quote included: my cost of doing business, scouting the location, planning with the restaurant owner, lining up restaurant employees to pose as customers and budgeting to pay those employees a small fee allowing me to secure signed model releases, parking fees, an assistant, digital postproduction, and the license requested. My estimate came to $3,200.

The marketing assistant thanked me for my time, but told me we were too expensive. I asked what they customarily pay for this type of assignment and she said $600 to $700. I have become accustomed to low budgets, but this was quite incredible. This manufacturer was looking to complete a commercial project with very specific parameters, released models, and a bundled license of rights for a budget comparable to a one-time use editorial assignment.

The confidence I have in how my estimate was determined made this job easy to decline. I know my business costs and the job requirements necessary to protect my business and the client. It seems unlikely that for the rate this client is used to paying that they hire photographers that carry liability insurance, quite a risk when ceiling fans fourteen feet in the air are to be cleaned and polished. It's also doubtful that that the employees and patrons modeling for images that will appear on the company's Web site will have signed proper model releases, yet another risk for the manufacturer. My guess is these risks will eventually surface as problems, at which time the client's willingness to pay professional fees may change.

Pricing professional photography even in good economic times requires careful consideration of many factors including how the images will be used, the photographer's cost of doing business, what the market will bear for the specific type of work, and the production needs of the project. Pricing in a tough economic climate adds an additional layer of difficulty. There are times when you may need to lower your price to get the work, but it is much wiser to negotiate a change in the parameters of the job rather than unilaterally lowering your fee. For example, a client needs four products photographed, three views each. Your estimate is over their budget. Rather than cutting your price, suggest they only do two views per product or use the same background for each image. The client gives something up and you can give on the price.

The biggest risk you take in lowering your fees in tough times is that a client will not be willing to return to the previous rates

when the economy improves. By working with clients wisely, such as reducing a job's production requirements or taking fewer views of a product, you can work with their currently tighter budgets without damaging your creative fees for the future. Remember that your fee structure is not a dartboard; your fees should be based on the costs of being a professional, the production needs of the assignment and the licensed use of the work. When you price based on specifics you can pinpoint, you can negotiate and defend your fees with confidence. This is one of the important distinguishing characteristics of a professional.

Register Your Copyrights and Submit Your Images to an Online Image Registry

In this age of online publishing, with the increasing ease of distribution with no quality degradation, it is vital that all photographers register their images with the Copyright Office. Copyrights are a privilege granted to creators, but it is only through registration that we acquire the full benefits of copyright law. Registration is not very expensive or difficult and should become part of your regular business practices.

Image registries, such as the nonprofit PLUS Registry described in chapter 6, are a necessary new addition to our business workflow. Created as a response to the expected Orphan Works copyright legislation, these image recognizable databases are the future link to monetizing the small online uses of our work, as well as providing confidence in our commissioning clients by openly guaranteeing their rights to use our work.

I encourage every artist to treat these two business basics, copyright registration and image registry submission, with the seriousness they deserve. Professional photography is not only a financial investment, it is also an investment of heart and soul. In order to ensure lasting respect and control of these assets, we need to seize these opportunities.

Business Management

Paperwork specific to the business of photography is critical to the professional execution of assignments and sales of your work. You can build custom forms or use one of the programs designed specifically for the industry. Either way, you must have a paper trail of your business transactions. Verbal agreements are open to each party's memory and interpretation, which will invariably lead to disagreements. The use of proper forms protects both you and your client and sets you apart as a professional.

Included in properly completed forms should be your terms and conditions of doing business. These terms and conditions protect you if any disputes arise over a project. Just like the terms of service you agree to before downloading software or signing up for Facebook; these contracts establish the rules for such things as who is responsible for securing necessary releases, where arbitration or litigation will take place, cancellation or postponement policies, and an indemnification clause protecting you from claims related to the client's use of your work. One of the most important components of these terms and conditions is the statement, "No rights are transferred to Client unless and until Photographer has received payment in full." With this contractual language in place, lack of payment by a client can become a matter of copyright infringement and, as discussed earlier, this condition combined with a proper copyright registration can facilitate getting paid by delinquent clients. A template for Terms and Conditions is available at *www.asmp.org/t&c*, but you should customize this contract for your own business. Additionally, it may be necessary to develop specific terms and conditions for different types of projects, for example wedding vs. advertising agency work.

The American Society of Media Photographers (ASMP) has sample forms with instructions available at *www.asmp.org/forms*, including estimate, assignment confirmation, change order, delivery memo, and invoice. I frequently handle the estimating phase in a more casual manner through e-mail and phone conversations. Once my client and I have agreed on price, I do a formal

assignment confirmation outlining carefully the description of the job, the license being extended, the price, the expenses, and my terms and conditions. I send this off as a PDF and require a signed copy (electronic signature is fine) before I begin the work. For many corporate and small business clients this approach works well. For estimates submitted to design firms and advertising agencies who are pricing photography services for a third party, more formal and detailed estimates will likely be required.

During the execution of an assignment the parameters of the job may change, in which case a change order form should be signed by the client or client representative. Doing this protects you from a client challenging cost increases based on only verbal approval.

Delivery memos should again contain your license and terms as well as offer specific guides for handling the digital media being delivered. A good practice is to make this form a PDF titled "read me" and include it inside the folder of digital files.

Invoices should contain all of the information from the assignment confirmation including any additional costs agreed to via change orders, any deposit paid, and the balance due. The invoice should not be the first time your client sees the licensing language or your terms and conditions. Just as a client cannot force you to sign a Work Made For Hire agreement after you have completed the assignment, you cannot expect the client to agree to your terms after the photography has taken place. Professional business practices demand that the terms of any contract be agreed upon prior to the work taking place; attempts to do otherwise are frequently unsuccessful and always unprofessional.

In addition to the management of the photographic-specific paperwork there are general bookkeeping needs to be met, including filing taxes, collecting and paying sales tax, managing payroll or contract labor, having proper equipment and liability insurance, as well as planning for your retirement. I recommend establishing a relationship with an accountant, insurance agent, estate planner, and a lawyer prior to any conflicts or troubles occur. Find people you are comfortable working with by seeking recommendations

and conducting interviews. Build a professional services team with care and they will serve as trusted counsel throughout your career. These business decisions are personal, so while advice from other photographers may be helpful, you need to realize the choices made by others may not fit your unique needs. With a professional services team in place, you have immediate support and guidance when issues arise. And in business and life, they always do.

Career Planning

Strategic career planning is an ongoing and fluid process that is critical to the success of any independent photographer. Most photographers today do not build a business from one type of work; rather we are hybrids, combining income streams from varied sources. A photographer holds an adjunct faculty position teaching photography while he also fulfills commercial corporate projects. A people photographer pursues weddings, event, and editorial assignments simultaneously. The tech savvy photographer who markets her own photography also offers digital production services to other photographers and businesses. A fine art photographer sells prints through a gallery, teaches workshops, and licenses his images online for commercial uses. A still photographer adds motion to her product offerings. A photojournalist fulfills magazine assignments and licenses personal projects to online media outlets. In our fast paced evolving industry, this patchwork income approach is essential, by diversifying where your money comes from you can build sustainability. The possible variations are endless; the trick is to strategically define what you want your unique career to look like. And it is advisable to periodically review this plan to address changes in your personal life, as well as evaluate new opportunities or challenges.

You need to identify your skill set and combine that with what you want to do. This can be a rigorous exercise requiring honest self-examination. You may benefit from a strategic planning guide or a consultant, but persevering through this task will make all subsequent business decisions easier. By establishing a targeted career plan, you will be able to filter specific business propositions;

such as an assignment, a job offer, a speaking engagement, or an interview, and assess whether the opportunity supports your long term goals or hinders them. Additionally, a defined career path is necessary to execute effective marketing and sales tactics that allow you to achieve your big picture objectives.

Marketing Plan and Sales Strategy

It is important to note that marketing and sales are related yet distinct activities. Much like understanding that copyright and licensing are linked, you need to effectively utilize both marketing and selling to build a sustainable business. Marketing is defining your message and setting the stage that delivers that message, through your portfolio, your Web site, your stationery, your e-mail promotions, your voicemail message, your dress, your tweets, your Facebook page, and the list could go on. Selling is when you actually interact with existing and potential clients, through estimating a job, the follow-up phone call, the negotiating, handling the production, the actual shoot, the thank you note after an assignment, and any personal interaction you have with your target audience.

As discussed in chapter 4, the need to define your message into what Burns calls your "Vision Marketing Statement" is your first step; you need to be able to concisely articulate the unique product and service you provide. With your mission clarified you can then: identify your goals as a business, define your target audience, establish a marketing budget, determine the best vehicles for your message, and build and use the tools to reach potential clients. Whether you are starting out or establishing a new direction for your business it is critical to take these strategic steps, each in their logical order. Building a Web site, for example, prior to establishing the goals of your business is simply a waste of time and money. Burns has developed a practical seven-step guide specifically for photographers. She writes,

> I don't think photographers are best served by writing highly
> technical marketing plans. Instead, I think a modified one
> which emphasizes goals, targeting, tools, budget, and sched-

*uling will give most photographers the guidance
they need without bogging them down with technical
business mumbo-jumbo that makes most photographers'
eyes glaze over faster than a beauty queen's at an astro-
physics convention.*[40]

Her refreshingly direct approach to marketing is a real asset for
our businesses and the complete plan (which is only seven pages
long) can be found in her book *Tell the World You Don't Suck:
Modern Marketing for Commercial Photographers* and in the *ASMP
Professional Business Practices in Photography.*

Marketing guru Seth Godin describes how, in today's changed
economy, we must incorporate marketing into all facets of our
business.

"'New Marketing' leverages scarce attention and creates
interactions among communities with similar interests. New
Marketing treats every interaction, product, service, and side
effect as a form of media. Marketers do this by telling stories,
creating remarkable products, and gaining permission to deliver
messages directly to interested people."[41] Everything we do as
professional photographers should strengthen our defined business
mission and goals.

Selling is where I believe many photographers fail. We put up a
beautiful Web site and send out a series of e-mail promotions, but
when the phone actually rings or when we reach out to a prospect,
we often stumble. Effectively communicating, which frequently
means careful listening, is a skill. When communicating with
clients, focus on their needs, not on your own. The challenge is to
accurately identify what the buyer needs or is concerned about
and then sell to that target.

Part of Richard Kelly's job as director of photography for WQED
in Pittsburgh was hiring freelance photographers for specific
assignments. Richard was excited about this opportunity and
strove to build good publisher/freelancer relationships with his
photographer colleagues. What he experienced however was
quickly disappointing.

"Photographers were not solving problems for me at WQED—they were creating problems." Richard had a visual and production problem that he needed solved—he contracted photographers to create an image to fill the specified need. By seeking affirmation for each logistical or artistic decision, these photographers required more handholding than Richard had time or desire to give. These photographers were not listening for or meeting Richard's expectations. He elaborates, "My experience on the hiring side of what we do made me better at my own work. I learned to communicate and lead. I learned to be part of a creative team. I learned to be part of the solution."

Blake Discher is a photographer, SEO consultant, and educator. He speaks nationally on the topic of negotiating and strongly advocates focusing customer conversations on how you will help them.

"Sell your value, not your product. By value, I mean the things I do that differentiate me from my competition. You've heard it many times: sell the benefits, not the product. Your product is photography, but what you need to share with the client are the benefits she will get in working with you." This is the true key to successful selling, and for photographers who are experiencing heavy downward pressure on our prices, it is critical. Discher continues, "Remember, if you focus the conversation on price, the price will likely fall. If instead you focus the conversation on value, specifically the value you bring to the project, you'll help the client justify in her mind why she should hire you for the shoot even though your price may not be the lowest."[42] Selling scares many of us, and if that is an accurate description of how you feel, take action to improve your selling skills by utilizing the aids outlined in the resources section of this chapter.

Business Resources

The following list is by no means meant to be comprehensive, rather, these are resources that have had lasting value to Sean Kernan, Richard Kelly, and myself.

The American Society of Media Photographers

ASMP has been a trusted industry resource for over 60 years. All of these resources are available at ASMP.org.

- Business Forms

- Copyright Tutorial

- Licensing Tutorial

- Model and Property Releases Tutorial

- Videos — A growing library of videos and podcasts on the business of photography.

(CARR, KERNAN, KELLY)

Books

ASMP Professional Business Practices in Photography, 6th Edition, ©2008

Considered the "bible" of the industry.

(CARR, KERNAN, KELLY)

..

Best Business Practices for Photographers by John Harrington, © 2010

Harrington's real world examples bring this sound business guide to life.

(CARR, KELLY)

..

Breaking Into the Boys' Club: 8 Ways for Women to Get Ahead in Business, by Molly Shepard, Jane Stimmler and Peter Dean, © 2009

This practical guide helps women (and men) better navigate tough business realities.

(CARR)

Copyrights and Copywrongs: The Rise of Intellectual Property and How it Threatens Creativity by Siva Vaidhyanathan, © 2001

A history of U.S. copyright law and its impact on business today.

(CARR)

Free, The Future of a Radical Price by Chris Anderson, © 2009

Anderson summarizes the history of "free" as a business tactic and profiles how the new online economy has accelerated its use.

(CARR, KELLY)

Googled: The End of the World as We Know It by Ken Auletta, © 2009

This biography of the search engine giant, Google, also serves as a history of the media industry's turbulent changes brought on by the Internet.

(CARR, KELLY)

The Linked Photographers' Guide to Online Marketing and Social Media by Lindsay Adler and Rosh Sillars, © 2010

The social media guide written by photographers for photographers.

(CARR, KELLY)

The Long Tail by Chris Anderson, © 2006

Anderson outlines how the Internet has given power to the niche market.

(CARR)

Meatball Sundae by Seth Godin, ©2007

Godin's mantra that a remarkable product is needed to succeed in the new economy.

(CARR, KELLY)

No Plastic Sleeves: The Complete Portfolio Guide for Photographers and Designers By Larry Volk and Danielle Currier, © 2010

The title speaks for itself. A companion blog is available at *blog.noplasticsleeves.com.*

(KELLY)

Pricing Photography by Michal Heron and David MacTavish, © 2002

An invaluable resource on estimating and negotiating photography assignments, includes pricing charts.

(CARR)

The Professional Photographers Legal Handbook by Nancy Wolff, © 2007

Written by a lawyer, but not like a lawyer, this is a clear and concise guide to understanding copyright.

(CARR)

Remix: Making Art and Commerce Thrive in the Hybrid Economy by Lawrence Lessig, © 2008

Lessig outlines why he feels the current copyright law is not working for the new Internet economy and offers options for the future.

(CARR, KELLY)

Tribes by Seth Godin, ©2008

A call for leadership based on passion.

(CARR, KELLY)

Tell the World You Don't Suck: Modern Marketing for Commercial Photographers by Leslie Burns, © 2008

Straight talk and practical application from an industry marketing expert.

(CARR)

Value Added Selling by Thomas Reilly, © 1989

Learn what it means to sell effectively.

(CARR)

What Would Google Do? By Jeff Jarvis © 2009

Richard: " This book is a business strategy for the Google age. How to add 'Google juice' to your business."

(KELLY)

Consultants

Leslie Burns (*burnsautoparts.com*)

Marketing Consultant

(CARR, KELLY)

Judy Herrmann (*2goodthings.com*)

Strategic Business Planning Consultant

(CARR, KELLY)

Suzanne Sease (*suzannesease.com*)

Creative and Business Consultant, Suzanne also offers estimating and negotiating services for high production photography assignments.

(CARR)

Mary Virginia Swanson (*mvswanson.com*)

Fine Art and Marketing Consultant

(CARR, KELLY)

Hands-on

ASMP Chapters (*asmp.org*)

39 Chapters offering educational events.

(CARR, KERNAN, KELLY)

ASMP Seminars (*asmp.org/calendar*)

Seminars designed for professional photographers.

(CARR, KERNAN, KELLY)

Mentoring

The Young Photographers Alliance (*YPA.org*) is a nonprofit organization offering mentoring and internship programs for student and emerging photographers.

(CARR, KELLY)

Photo Plus Expo Annual Conference (*photoplusexpo.com*)

This annual fall industry event brings together industry experts for an unprecedented line up of seminars and trade show opportunities.

(CARR, KELLY)

Licensing

Creative Commons (*creativecommons.org*)

A nonprofit corporation offers free pre-written licenses for artists and authors to facilitate legal sharing of content with various degrees of restrictions.

(CARR, KELLY)

Photoshelter (*photoshelter.com*)

Offers Web site and e-commerce services for photographers.

(CARR, KELLY)

The Picture Licensing Universal System (*useplus.org*)

PLUS is a nonprofit initiative created to help users and creators clarify and standardize the image licensing process. The PLUS Glossary is the licensing language standard in the industry. The PLUS registry connects images, rights holders, and rights information.

(CARR, KELLY)

Online Image Tracking Services

Tools to locate your images online.

- Digimarc (*digimarc.com*)
- Image Rights (*imagerights.com*)
- PicScout (*picscout.com*)
- TinEye (*tineye.com*)

(CARR, KELLY)

adage.com

Richard: "Daily resource and news on the advertising and design business."

(KELLY)

··

adbase.com/Insight

ADBASE, a database and marketing service for the creative industry, offers this online newsletter on marketing your business.

(CARR)

··

agencyaccess.com

Agency Access, a database and marketing service for the creative industry, offers online marketing tips through their "Inspirations" online resource.

(CARR)

··

aphotoeditor.com

Rob Haggart publishes this blog daily covering industry news, interviews, and thought-provoking commentary.

(CARR, KELLY)

··

asmp.org/strictlybusiness

ASMP's daily blog offers contributions from experts in the professional photography community.

(CARR, KERNAN, KELLY)

··

creativity-online.com

Richard: "An online magazine with daily news and resources for the design community."

(KELLY)

··

..

marketingphotos.wordpress.com

The blog of marketing consultant Mary Virginia Swanson offers updates and deadlines on exhibition and grant opportunities.

(CARR)

..

photoshelter.com

Photoshelter offers free Webinars and video tutorials on marketing your images online.

(CARR)

..

plagiarismtoday.com

Plagiarism Today is a site targeted at Webmasters and copyright holders regarding the issue of plagiarism online.

(KELLY)

..

sethgodin.typepad.com

Marketing guru Seth Godin shares insights on succeeding in business.

(CARR, KELLY)

..

2goodthings.com

2GoodThings—Strategic Career Reinvention with Judy Herrmann.

(CARR, KELLY)

..

Chapter 10

CRAFT

The American Heritage Dictionary defines craft as, "Skill in doing or making something, as in the arts; proficiency." The idea of hands-on work is not as literal for a photographer as it is for a sculptor with a block of wood or a ceramicist with clay, but we are craftsmen and we can and should nurture this way of perceiving our process. Watch an experienced photographer at work, notice the way she holds her camera, her subtle body movements to get the desired angle of view and the seamless way she manipulates the camera settings as if the tool is an extension of her hands. This is craft.

Richard Sennett discusses the process of mastering a skill in his book *The Craftsman*, ". . . Ten thousand hours is a common touchstone for how long it takes to become an expert . . . This seemingly huge time span represents how long researchers estimate it takes for complex skills to become so deeply ingrained that these have become readily available, tacit knowledge." Photographers need to revisit craft, we need to consciously slow down our work process and reconnect with image making. Technology can add efficiencies, but we must resist the notion that these tools allow us to skip the craft component of our artistry. Sennet continues, "The ten-thousand-hour rule translates into practicing three hours a day for ten years, which is indeed a common training span for young people in sports. The seven years of apprentice work in a medieval goldsmithy represents just under five hours of bench work each day, which accords with what is known of the workshops. The grueling conditions of a doctor's internship and residency can compress the ten thousand hours into three years or less."[43]

Commitment becomes the true measure (and test) of learning a craft. I am not insisting every photographer become an expert in all photographic techniques prior to working professionally, but I am stressing that we acknowledge the importance of good craftsmanship and that we continually strive to better the skills we use in creating imagery.

Craft appears to be lower on the priority scale in contemporary photography. Galleries, museums, and schools emphasize concept over process, yet technique and vision are linked. This imbalance creates a problem. Unlike the past, when technical training dominated art education, we now readily accept if a particular skill doesn't come easily and simply fall back on the excuse, "I am not good at that." James Elkins in his book *Why Art Cannot Be Taught* discusses the falsity of this notion.

"The tens of thousand of drawings by Baroque academy students, held in museums throughout Europe and America, show that basically anyone can learn to draw a figure with reasonably correct proportions." Good technique can be learned, but it appears we frequently lack the motivation and perseverance necessary to perfect our craft. Elkins continues explaining that, "Everything difficult about drawing begins after proportions are no longer an issue,"[44] but if the technique is never mastered, how can you develop your work into genuine expression?

Richard Kelly had an ulterior motive when he took the Director of Photography position at WQED in Pittsburgh. He was shooting digital capture prior to taking this staff position, but he knew his skills in this new technique were not at the high level of his film work. The job at WQED allowed Richard the time and resources to learn digital photographic technique; he attended workshops, developed a color management system for *Pittsburgh Magazine* and created digital submission guidelines for the freelancers he hired. He was also there when the magazine started printing direct to plate and stopped doing press proofs.

"They saved money, but the lack of proofs caused lots of trouble. It was a fantastic learning experience for me to be on the

client side during this industry transition." Richard feels the best compliment he was given in the days when the industry was making this shift was that people couldn't tell if he was using digital or not. "I love that. I learned a new craft, but I wanted to maintain the look of my film work and I succeeded." Richard wisely recognized that he needed to learn new skills to keep his art and his business progressing and he found a viable solution.

In this age of digital technology and downward pressure on fees, few photographers have not fallen victim to, at least occasionally, allowing craft to slip in exchange for expediency. When clients are asking for more work produced for less compensation, the urge to simply comply and get the work done with shortcuts is tempting, but the long-term effect of these choices is a diminishing of our craft and, consequently, our value.

The days of large format cameras, film, and darkrooms kept us more rooted in hands on work and the demise of working this way creates a challenge for us. Sean Kernan laments, "Time is being taken away beside the camera as much as behind the camera." In other words, we need to think about the process and make decisions based on the needs of the image rather than a desire for ease or speed. Sean continues, "Craft is clear speech. It doesn't exist apart from what it is applied to."

As Sennett further notes, our craft is vital in the realization of our vision. "Technique has a bad name; it can seem soulless. That's not how people whose hands become highly trained view technique. For them, technique will be intimately linked to expression."[45] We need to find ways to use the new tools that technology provides in concert with craft. For some photographers the process of photographing may stay very much the same, but those stills may now be incorporated into an animated video producing a new presentation format. For others, they may spend less time taking pictures and more time building the final image on the computer, but this is no different than the time and dedication Jerry Uelsmann gave his darkroom techniques in pursuit of his vision. Strive to treat the imaging work done on your computer with the respect and care it deserves.

High Dynamic Range Imaging (HDRI) is the technique of merging layers of exposures yielding one image with more luminosity in the darkest and lightest areas of the scene than a conventional one frame capture is capable of. The ease with which this technique can be applied has dramatically reduced if not eliminated the amount of lighting many photographers use. For some, this technique may more fully express their vision than single capture photography can, but for others, it is simply expedient. Make sure the choices you make for how you create images matches the intention behind those images in order to fully express the quality of your vision.

Staying open to new options, such as utilizing new DSLR video cameras or old techniques made available by access to alternative process materials, is a challenge to be embraced. David Bayles and Ted Orland, both practicing artists and co-authors of *Art and Fear*, describe the process.

"The dilemma every artist confronts, again and again, is when to stick with familiar tools and materials and when to reach out and embrace those that offer new possibilities." The tools we are familiar with feel comfortable, but often pushing ourselves to try something new yields lasting rewards. Bayles and Orland continue, "In time, as an artist's gestures become more assured, the chosen tools become almost an extension of the artist's own spirit. In time, exploration gives way to expression."[46]

No photographer embodies the idea of the exploration of craft in the pursuit of vision more so than Barbara Crane. Crane started her professional career in New York City doing portrait work before returning to her native Chicago to study with Aaron Siskind at the Illinois Institute of Technology. Her distinguished teaching career started in 1967 at the Art Institute of Chicago where she taught for 28 years. She received a National Endowment for the Arts Grant in 1974 and a Guggenheim fellowship in 1979.[47]

Crane consistently pushes herself by embracing a variety of techniques and materials. Her early work includes a series of nudes using very high-key lighting technique, which evolved into sequences and then into layered images combining the human

form with urban landscapes. She created double exposures by shooting rolls of isolated neon signs and then re-exposed the film capturing the faces of people in the bustle of city life. Crane continually explores sequencing, repetition, and scale in her work to visually express her ideas. Her single large format images of Chicago architecture also reveal her affinity for form; these images have the same strong sense of movement and visual punch found in her multi-image grid creations. Crane worked in color photographing people and still lifes and embraced the Polaroid transfer process with great intensity. The skill and patience necessary to create single paper-sequenced large format transfers both amazes and inspires me.

With such a varied technical background it was no surprise to me when, in 2002, I walked into the Museum of Contemporary Photography and saw an exhibit of Crane's new digital color images. I was still struggling with mastering this new technique, but here she was fully embracing it at age seventy-four.

When Richard started his "Artist and Scientist Series" in 2001 he chose to produce the portraits using Polaroid's large format black and white positive/negative film. He loves the quality of material, particularly the richness of the prints these negatives yield. In the prints he shows the film edge, which visually frames the subjects while simultaneously revealing the process, adding his mark as photographer. In the midst of this project this Polaroid material was no longer available and Richard faced a quandary. The Polaroid material and the 4 × 5 camera were integral, both technically and aesthetically, to his concept of this project and the frustration of losing this film mid project was paralyzing. Upon reflection, Richard realized that due to time and location constraints, he had already been forced to create some of the portraits using smaller format cameras, meaning he had actually already broken his own prescribed methodology. Perhaps a technique, originally thought to be essential to the outcome of the project, was not as critical as presumed.

Projects have lives of their own and the loss of available materials led Richard to understand this clearly and move

forward. While the logistics are still unresolved, he plans to make this story, this struggle in craft, part of the project. The resulting new work will undeniably alter the series, yet the challenge fits the theme of investigating his ideas of art and science through practitioners.

Experimentation is critical if we're to develop fully as artists, but for commissioned work it's critical that you have the necessary skill set to complete the assignment. While much has changed in this business, this truth has not, as expressed in the *1978 Photographer's Market*: "Suppose someone offers you an assignment shooting zoo animals, but you have never in your life pointed a camera at anything that moved. However, the money is good—great, in fact. So you take the assignment. And produce a series of mediocre photos. The money you have in your hand in no way matches the money you have lost by failing a customer."[48] This sound business advice is timeless, so do not be tempted, even when business is slow, to take a job you are not prepared for.

Many years ago my business partner and I took on a fashion shoot. It was for a uniform manufacturer, nothing glamorous. Like most fashion work it required using professional talent photographed on location and the clothes had to look good, uniforms or not. We had never done fashion, we had no interest in pursuing this kind of work, but we took the job anyway. The results were mediocre at best. The client was polite which speaks to his character not the quality of our work, but he never hired us again. Challenge your technique on your own time and money.

As discussed in chapter 4, the past decade dramatically changed how businesses advertise. Online advertising grew at a feverish pace as Ken Auletta shares.

"Google's ad revenues in 2008 matched the combined advertising revenues of the five broadcast networks. By 2011, Web advertising in the United States was expected to climb to sixty billion dollars, or 13 percent of all ad dollars."[49] More businesses are using the Web, both in advertising and their own sites, as their major

marketing tool and the technical requirements of imagery displayed online is different than print. While many photographers groan that clients have stopped wanting high quality imagery, the reality is that the move from print to online use is likely the reason client requests are changing, not a sudden lack of caring. The shift away from what many photographers perceive as "quality" is really a shift to publishing in a different medium.

This new publishing platform has its own unique needs and, as craftsmen, we must identify and meet these new challenges for our clients. Properly preparing files for online viewing now frequently trumps any need for high resolution. Lighting and composition concerns have to be analyzed from the perspective of displaying on a small mobile device. As new products such as the iPad are introduced, the craft needs of our work will continue to evolve. These changes are not good or bad, they are just realities. You can utilize any technique you choose for your own work, but you have to be conscious of the client's needs when you execute your skills on their behalf.

The Greek word for craftsman, *demioergos*, combines two ideas, public (*demios*) and production (*ergon*). In Ancient Greece, this role of making things for the community was valued and, in keeping with this, the Ancient Greek god of the craftsman, Hephaestus, was celebrated as a bringer of peace and a maker of civilization. Symbolically, the temple to Hephaestus in Athens was built inside the agora, the marketplace of the city and the center of public life. Ancient Greece relied on its community of artists to pass on skills necessary to build what the public needed.[50]

This notion may sound rather lofty to put in association with contemporary photographic craft; however, today's frequently isolated working environments demand that it be considered. We need each other to solve the fast-paced challenges of technology, and only through utilizing our collective knowledge can we continue to nurture our skills. We can't do it alone, and, as Richard articulates, "You can't stop and say you know enough. I like the idea of serendipitous mistakes, but if you don't know your craft you don't know what happened. You can't repeat it. You need to

know your craft so you can get back to it when the great idea happens." By professionally dedicating the time and care necessary to perfect your craft, you can move away from the current state of abundant image mediocrity, combine it with a vision and message, and your art can truly flourish.

Craft Resources

The following list is by no means meant to be comprehensive, rather, these are resources that have had lasting value to Sean Kernan, Richard Kelly, and myself.

Books

The Craftsman by Richard Sennett, © 2008

Sennett argues the importance of craft, its role in our history, and cultural benefit.

(CARR)

...

The DAM Book: Digital Asset Management for Photographers by Peter Krogh, © 2009

Krogh outlines how to efficiently and effectively manage all your digital files.

(CARR, KELLY)

...

Digital Photography Best Practices and Workflow Handbook by Patricia Russotti and Richard Anderson, © 2010

This book outlines best digital imaging practices and workflow solutions.

(CARR, KELLY)

...

Night & Low-Light Photography by Jill Waterman, © 2008

This is the resource for night photography technique.

(CARR)

Hands-on

ASMP Seminars (*asmp.org/calendar*)

Seminars designed for professional photographers.

(CARR, KERNAN, KELLY)

...

Fellow Photographers

Nothing trumps one on one tech help from a colleague.

(CARR, KERNAN, KELLY)

Mentoring

The Young Photographers Alliance (*YPA.org*) is a non-profit organization offering mentoring and internship programs for student and emerging photographers.

(CARR, KELLY)

Museums

Sean Kernan shares, "The biggest learning resource ever for me was the Museum of Modern Art [MOMA] print collection. I visited there often in my early career, and they would bring out boxes of Ansel Adams, Robert Frank, Diane Arbus, anyone at all, and I would just look for hours. As a result I saw photographs the same way those photographers did, in the hand, as silver prints, untranslated into offset printing or pixels. You can still do this, and my guess is that any of the many museums that have photography now will let you handle them in this way."

(CARR, KERNAN, KELLY)

Photo Plus Expo Annual Conference (*photoplusexpo.com*)

This annual fall industry event brings together industry experts for an unprecedented line up of seminars and trade show opportunities.

(CARR, KELLY)

Workshops

Workshops can be life changing, offering you an opportunity to focus entirely on your work for a concentrated period of time.

- Anderson Ranch (*andersonranch.org*)
- Maine Media Workshops (*mainemedia.edu*)
- Santa Fe Photographic Workshops (*santafeworkshops.com*)

(CARR, KERNAN, KELLY)

Movies

Chuck Close: A Portrait in Progress, Directed by Marion Cajori, © 1998

This documentary is a testimony to the pursuit of craft excellence.

(CARR, KELLY)

Online

dpBestflow.org

This is the comprehensive online guide to digital photography best practices and workflow, an ASMP initiative funded by the Library of Congress.

(CARR, KELLY)

thefstopmag.com

Richard: "Online photography magazine features photographer interviews on craft."

(KELLY)

jkost.com

Julianne Kost is a digital imaging evangelist for Adobe Systems offering her expertise on Photoshop and Lightroom in this easy to navigate Web site.

(KELLY)

lynda.com

Digital training tutorials on digital tools and techniques.

(KERNAN, KELLY)

strobist.blogspot.com

Richard: "This blog offers creative approaches to lighting on a budget. The behind the scenes videos are inspiring."

(KELLY)

joemcnally.com/blog

Richard: "McNally shares techniques on planning and implementing of complex lighting assignments."

(KELLY)

Chapter 11

CREATIVITY

The true value of all that we do is found in our unique expressions. Being creative is production by original thought or imagination. Taking a photograph, developing a unique marketing idea, devising a new business direction, solving a visual problem for a client, or applying a new technical skill to a presentation are all examples of creativity in practice. Nurturing this practice by giving it mindful time, being persistent, and staying open to the unexpected are critical to the success of any professional artist.

Mindful Time

The creative process requires time and attention in order to achieve results, the evolution of our creativity cannot be rushed or forced. Moments of creative inspiration are often characterized as a thunderbolt striking, but the truth is that those flashes of inspiration occur because we have laid a solid foundation and are dedicated to the task at hand. This can be a challenge in the fast paced, frequently online, multitasking lives most of us lead. Writing this book, for example, while simultaneously checking my e-mail and answering the phone is not a productive way to work. Setting aside blocks of uninterrupted time to write allows for focused thought and increased productivity, and photography is no different.

Writing in *Wired* magazine Nicholas Carr discusses recent scientific studies on brain functions related to Internet use. He illustrates that the growing time we spend online harms our ability to concentrate by increasing the use of our prefrontal cortex. This is the part of the brain that is responsible for problem-solving and

decision-making. Increasing the use of that part of our brain may seem harmless enough, perhaps even helpful, but as the pace of that work accelerates, long-term memory and understanding are negatively impacted. Carr writes: "Navigating linked documents, it turned out, entails a lot of mental calisthenics—evaluating hyperlinks, deciding whether to click, adjusting to different formats—they are extraneous to the process of reading. Because it disrupts concentration, such activity weakens comprehension."[51]

Have you ever had dinner with someone who is texting another friend or checking e-mail? You may be having a pleasant time, but you are not both entirely participating in the experience. Or consider watching television by channel surfing. You may walk away with a rough outline of three or four programs, but you will likely not be able to share the complete narrative of even one of the shows.

Build breathing (and thinking) room into your day. Try putting limits on checking e-mail, for example, or take a walk with only your camera. By concentrating on single tasks, we can redevelop the ability to keenly focus and this skill is imperative for our artistic development. If we allow for periods of concentration and add to it scheduled time for doing personal photography, we will improve our work and our businesses.

Persistence

Gary Cialdella published his photographic project, *The Calumet Region, An American Place* in 2009. He began photographing the area that includes south Chicago and Northwest Indiana in 1986. For 20 years, he consistently dedicated time and resources to photographing this place; searching for new vantage points and undiscovered alleys, utilizing various camera formats, editing imagery and experimenting with presentation, talking to the people, taking in local places, mourning the loss of buildings and the closing of factories, watching in awe the re-vitalization work and applauding the environmental cleanups. As a documentary photographer, Gary knew he could not do justice to this place he loved without truly experiencing it. In spite of concerns that this

Calumet work would never get the true exposure he wanted, he returned again and again to these particular streets.

When viewing the images in this book it is strikingly apparent that this is a thorough and mature artistic exploration—the photographs are beautifully subtle and moving. The book's essays, design, and sequencing strengthen and support his vision of this fascinatingly complex social landscape. The resulting book is a dream come to fruition, the quality of it is a testament to the critical relationship of persistence and the creative process.

Contemporary culture frequently fosters hastiness and artists need to resist this frantic pace and strive instead for the patience essential to achieving artistic maturity.

Openness

We must keep ourselves open to allow for conscious creativity. We must, as Sean Kernan describes, "be able to court discomfort." When hired to do commissioned work, a photographer must orchestrate the outcome by careful planning to effectively limit risk, which is what clients expect and compensate us to do. In our own creative work, however, we must let go of that control. Sean explains,

> Normal process is that the Object, the outside thing, encounters the 'eye' or sense of seeing. Those two aggregate with consciousness to make up a perception. This perception is then brought to the mind for judgment, analysis, to have the meaning of it determined (i.e., we like what we see or we don't, we fit it into the narratives our minds are always constructing). In essence we take new material and strain it through the cheesecloth of what we already know and decide its meaning. And we take that meaning as intrinsic and absolute.

> But our real creative breakthrough work happens when we are turned sharply from that usual process, when we postpone the judgment and stay floating in awareness, allowing something deeper and wider to happen. Call it an insight, an inspiration.

It comes from getting into a state of empty cognizance,
awareness without judgment. And the longer we refrain from
wrapping it up, the fuller it gets.

Sean was the keynote speaker for two of ASMP's 2008 Strictly
Business 2 conferences. I organized the curriculum for these
events and after a day of lectures focusing on photography busi-
ness essentials, I felt we should end by talking about the creative
part of our jobs; Sean's experience as a photographer and scholar
on the creative process made him the perfect choice. Sean started
in a conventional mode, shared a little of his career history, his
falling in love with photography tale, his entrance and ultimate
success in the commercial world. Sean next movingly expressed
his concern for the lost artist; photographers who have learned to
create on demand for clients, but can no longer create for them-
selves. He abruptly asked for volunteers, instructing 20 attendees
to stand in a circle in front of an audience of over 200, he pointed
at one person on each side of the circle and told them to respond
to the recorded music he had prepared. When they reached the
other side of the circle they were to choose the next participant.
He asked them to not think about anything, only to respond. With
hardly any time to digest the directions, Sean hit the on switch of
the CD player and the two designated photographers spontane-
ously broke into dance, moved across the circle, and reached out
to another volunteer. Sean then changed the music and the next
two volunteers began to dance.

That's when I experienced a brief moment of terror. I thought,
what is he doing? This carefully planned conference, designed to
help photographers improve their business skills, was turning
rather groovy. Would people walk out, rebel? My fears quickly gave
way to delight as the dancing continued uninterrupted for more
than 15 minutes, onlookers jumped on their seats to get a better
view, clapping and swaying with the music. The audience's
delight at this unfettered creative expression was undeniable.
Sean had made his point: we need to be open, to unleash, to create
without questioning or planning, to discover the artist within.

Conveniently, and also rather harshly, the final product of our labors reveals to us directly the extent of our commitment. While it is not always easy to acknowledge, as Bayles and Orland articulate, the answers are there in the work.

> *The world displays perfect neutrality on whether we achieve any outward manifestation of our inner desires. But not art. Art is exquisitely responsive . . . The breathtakingly wonderful thing about this reaction is its truthfulness. Look at your work and it tells you how it is when you hold back or when you embrace. When you are lazy, your art is lazy; when you hold back, it holds back; when you hesitate, it stands there staring, hands in its pockets. But when you commit, it comes on like blazes.*[52]

There are no short cuts in the pursuit of making art; the quality of our work will grow in direct proportion to the effort put forth. The power here is that by applying these principles of time, dedication, and freedom we have the keys to creating honest and thoughtful work. The necessary leap is simply to begin.

Creativity Resources

The following list is by no means meant to be comprehensive, rather, these are resources that have had lasting value to Sean Kernan, Richard Kelly, and myself.

Books

Art and Fear by David Bayles and Ted Orland, © 1993

This book provides direct and powerful insights on the struggles of creating art. Sean adds, "Readers will recognize the commonness of their concerns."

(CARR, KERNAN, KELLY)

..

De Kooning: An American Master by Mark Stevens and Annalyn Swan, © 2004

This biography is an exquisite portrait of persistence.

(CARR)

..

Dzogchen: The Self-Perfected State by Chogyal Namkai Norbu, © 1990

Sean: "This is about a Tibetan meditation practice that is quite impossible to sum up. But basically it works with what is there in the mind and the eye, rather than working toward any particular certain state as a goal."

(KERNAN)

..

The Empty Space by Peter Brook, © 1968

Sean: "Peter Brook changed the way Shakespeare is done by looking past all of the accretions of style and interpretation and focusing on what each moment of each play is about and bringing that to life, as opposed to working to sound and look Shakespearean and archaic."

(KERNAN)

..

The Feeling of What Happens, by Antonio Damasio, © 1999

Sean: "Damassio is one of the pioneers of modern neurobiology, and he manifested the idea of things manifesting in the mind/brain before they have any possibility of being articulated. From him I got the idea of 'Wordless knowledge.'"

(KERNAN)

Improvisation for the Theater, Viola Spolin, © 1963

Sean: "The first book about this form. Improv works by undercutting your plans and expectation in such a way that you actually enjoy it and are expanded."

(KERNAN)

The Ongoing Moment by Geoff Dyer, © 2005

A delightful and thought provoking stroll through the history of photography through the repeated subjects and themes pursued by various photographers.

(CARR)

Pedro Paramo by Juan Rulfo, © 1955

Sean: "A novel that inspired Gabriel Garcia Marquez to write. It is layered, haunting, and it leaves the reader to assemble it in his own mind. Susan Sontag said it is the product of taking out what is not needed and seeing how the story works with mainly hints."

(KERNAN)

The Perfect Wrong Note by William Westney, © 2006

Sean: "Practical ways of finding music in one's self. Bill co-taught a class with me, and the translation of his exercises from music to photography was perfect. I use many of them still."

(KERNAN)

..

The Viewpoints Book by Anne Bogart and Tina Landau, © 2005

Sean: "An acting training that uses exercises for exploration. The power of the exercises is that they start with simple tasks, not with ideas and concepts. It is a different door into awareness."

(KERNAN)

..

A Whack on the Side of the Head by Roger Von Oech, © 1983

Richard: "This is literally a creative whack."

(KELLY)

..

Why People Photograph by Robert Adams, © 1994

Fellow photographer Robert Adams explores the motives for creating photographs. The book includes elegant profiles of Edward Weston, Paul Strand, Laura Gilpin, Judith Joy Ross, Susan Meiselas, Michael Schmidt, Ansel Adams, Dorothea Lange, and Eugène Atget.

(CARR, KELLY)

..

The World is Flat by Thomas Friedman, © 2007

Richard: "This book puts into perspective our true place in a connected globe."

(KELLY)

..

Zen in the Art of Archery by Eugene Herrigal, © 2005

Sean: "Not about how to hit the target but how to be the target. Herrigal studied with a Zen archer and entered into the world on doing without 'Doing.'"

Sean further notes, "I also read a ton of fiction. The exercise of the imagination is indispensable for seeing practice. Currently climbing Mt. *Ulysses* by Joyce."

(KERNAN)

..

Fellow Photographers

Take advantage of opportunities to attend fellow photographers' exhibitions and lectures. Share your work with your colleagues and take the time to look at their latest images.

(CARR, KERNAN, KELLY)

..

Fotofest (fotofest.org)

This biennial Houston, Texas event highlights, through exhibitions all over the city, contemporary photographic works. In addition, Fotofest offers highly regarded portfolio review sessions, but register early—the slots fill up six months in advance.

(CARR, KELLY)

..

Galleries

Do not limit yourself to photography galleries. Take in as much as possible both in your home area and when traveling.

(CARR, KERNAN, KELLY)

..

Museums

Sean Kernan shares, "I will go to any museum at all for nourishment (though not so much photography museums or departments). In particular, I love the Met and MOMA. I also do Art Dates trooping through the galleries of Chelsea."

(CARR, KERNAN, KELLY)

..

Society for Photographic Education Conferences

SPE hosts annual regional and national conferences featuring artist tracks where photographers share current projects.

(CARR, KELLY)

..

Workshops

Workshops can be life changing, offering you an opportunity to focus entirely on your work for a concentrated period of time.

- Anderson Ranch (*andersonranch.org*)
- Maine Media Workshops (*mainemedia.edu*)
- Santa Fe Photographic Workshops (*santafeworkshops.com*)

(CARR, KERNAN, KELLY)

Movies

Rivers and Tides, Andy Goldsworthy Working With Time, © 2003

Sean: "Goldsworthy works with simple natural objects to make time-based 'sculptures' (there isn't a better word), most of which deteriorate with age."

(KELLY)

From the East by Chantal Akerman, © 1993

Sean: "This introduced me to a radical and engaged documentary style, shows rather than tells and allows rather than shows. Amazing work."

(KELLY)

Playing Shakespeare, directed by John Barton, © 1984

Sean: "A BBC series with Patrick Stewart and other greats that takes one into the Bard's work by awareness, not analysis. Nothing wrong with analysis, but it is not the only tool, or the respectable one."

(KERNAN)

accidentalcreative.com

Richard: "Creative and productivity advice for professionals. I like to download the podcasts."

(KELLY)

...

creativethink.com

Richard: "This is from Roger von Oech, author of *A Whack on the Side of the Head*. I like the iPhone app."

(KELLY)

...

Interviews by Charlie Rose (*charlierose.com*)

Interviews covering an endless variety of topics on politics, business, culture, and art. Sean Kernan particularly likes the Richard Sera interview from 2002. Richard Kelly likes the Chuck Close interview from 2007.

(CARR, KERNAN, KELLY)

...

commarts.com

Richard: "*Communications Arts Magazine* online features and columns for the design community."

(KELLY)

...

fractionmag.com

Richard: "Online magazine featuring contemporary photography."

(KELLY)

...

flakphoto.com

Richard: "Web site featuring photographers' new work, book projects and exhibitions."

(KELLY)

...

lenswork.com

Richard: "I particularly enjoy the podcasts on this online version of the print magazine. Lenswork covers the art and craft of photography."

(KELLY)

Library of Congress (*loc.gov/pictures/collection/fsa*)

Affordable public domain art available here. You can view the photographs from the Farm Security Administration and order prints of photographs by Walker Evans, Dorthea Lange, and others.

(CARR)

TED Conferences (*ted.com*)

TED stands for technology, entertainment, and design and these conferences bring together the big thinkers in these areas. This site hosts all the speaker videos from these conferences, searchable by speaker names or themes.

(CARR, KELLY)

Other Artists

Susan Carr is inspired by Berenice Abbott, Lorenzo Bernini, Eugene Atget, Roy DeCarava, Walker Evans, Lee Friedlander, Edward Hopper, Wright Morris, Richard Neutra, Louise Nevelson, Johannes Vermeer, and Frank L. Wright.

Richard Kelly is inspired by Richard Avedon, Chuck Close, Robert Frank, Donald Judd, Art Kane, Annie Leibovitz, Kurt Markus, Norman Mauskopf, Arnold Newman, Herb Ritts, August Sander, Sebastiao Selgado, W. Eugene Smith, and David Vance.

Sean Kernan is inspired by Christian Boltanksi, Robert Frank, Chung-ho Frankel, Andy Goldsworthy, Duane Michals, Irving Penn, Tino Seghal, and Richard Sera.

Additional Notes

Richard shares, "I look for inspiration by following my curiosity. I go to "old" hardware stores, used book stores and flea markets. I do random word searches using Internet search engines."

Sean shares, "Like most artists, I'm an introvert, in the sense that I 'turn inward,' literally bringing things inside and then re-manifesting them in the form of work, thoughts, writing, and just spouting off. Oddly enough, I tend to find inspiration mostly outside of photography, and the ones that work best are the ones that blindside me and bowl me into some new awareness."

Chapter 12

CONCLUSION

As a student, I spent many hours in the stacks of the university library studying the photographs of the accomplished masters. It was in this manner that I discovered the work of Roy DeCarava, an American photographer who photographed the people and places in the Harlem neighborhood of New York City for over fifty years. I remember being immediately grabbed by his images and then being simultaneously puzzled by their power. In particular an image titled *Man in Window, 1978*, which shows a shirtless man sitting solemnly inside an apartment framed perfectly by the window, remained with me. The image, taken presumably at night, is slightly soft and printed with a zone V gray as its lightest tone. This photograph broke every rule I was being taught in my photo classes, yet it would not let go of me. It was the most powerful image I had encountered.

The Museum of Modern Art in 1996 launched a long overdue retrospective of DeCarava's work. This beautiful collection traveled the country and I was fortunate enough to hear the artist speak at the Art Institute of Chicago in connection with this exhibition's Midwest stop. With humor and humility he discussed his creative process and to my delight, remembering the power of my college experience, DeCarava explained arriving at those dark brooding images.

He shared being told by teachers that he couldn't execute handheld photography below 1/30 of a second. This matched my school instruction, but DeCarava asked, "Why not?" The camera will, in fact, function if, while handholding it, one releases a shutter set below that speed. The image may not be tack sharp, but that

particular descriptor for quality photography is not one DeCarava felt compelled to follow. This artist wanted to capture the life inside Harlem jazz clubs where light levels are habitually low, he wanted to wander the city streets at night and walk into the apartment buildings, subway stations, and businesses of the neighborhood. And working with a tripod was not going to match his desire to catch the ephemeral moments he saw before him. So DeCarava simply ignored the 1/30 of a second rule and photographed.

DeCarava further recalled a similar process in his darkroom: he would print using conventional standards and the work simply did not feel right. So he would print the image darker, and then even darker, and then one step more, finding that only when these images were far darker than many thought "correct" did they express what he wanted. We are blessed by DeCarava's willingness to break rules and push his vision in the pursuit of a larger purpose. The resulting body of work is here for us to experience, it is a gift.

The concept of art as a gift is sound, we have all undoubtedly, at some point, been moved by a piece of art, whether the work reveals a depth of emotion not previously experienced or a new way of seeing something we formerly thought to be clearly defined. If we are fortunate, a viewer of our photographs has experienced this same phenomenon. The feeling on the giving or receiving end of the art exchange is quite literally priceless. Our creations must, however, find a way to successfully enter the commercial space, if our goal is a professional career.

Lewis Hyde in his book *The Gift* discusses the precarious balance of what he refers to as the gift and commercial economies: "The artist who sells his own creations must develop a more subjective feel for the two economies and his own rituals for both keeping them apart and bringing them together. He must, on the one hand, be able to disengage from the work and think of it as a commodity . . . And he must, on the other hand, be able to forget all that and turn to serve his gifts on their own terms. If he cannot do the former, he cannot hope to sell his art, and if he cannot do the latter, he may have no art to sell."[53] The life of an independent working photographer requires dedication to both the art and

business sides of our chosen vocation. The two are exceedingly different pursuits, one striving for genuine personal expression while the other works to fill the needs of paying customers. Only by consciously recognizing this distinction can we work to maintain a productive equilibrium.

Technology both disrupts businesses and fosters new opportunities. Digital photography made the ability to properly expose transparency film an unneeded skill and film unessential. Both of these changes damaged the photographic lab business. Web sites as a means to show our portfolios hurt messenger and delivery services. The Internet allows us to shop worldwide for the cheapest supplies and the local camera store closes its doors. Electronic signature capabilities remove the need for a fax machine or the second phone line. Cell phones eliminate the need for a land phone line. Inexpensive server space makes multiple Web sites targeting niche markets affordable. We may find it frustrating that our cameras are obsolete in three years, but I can assure you that camera manufacturers do not. Image recognition software combined with powerful Internet search abilities creates a threat to major stock photography channels and a win for the independent photographer with images online.

Since the inception of our medium photographers have been on both sides of this struggle. An art that relies on mechanical tools can expect little else. We must reframe our thinking about these technology and business conundrums—they are neither problems nor solutions. We must empower ourselves to think beyond these changes and focus instead on the ultimate purpose of expression. Our means will change, but our intent is constant.

Photographers need to administer and encourage professional business practices, focus on uniqueness (rather than conformity), master what we create (rather than just getting by), and apply all three to the marketable service of being extraordinary visual communicators. With deliberate steps, we can each make our visionary profession, which both records and changes our world, a meaningful choice for our life's work. We must, as DeCarava did, see the final image in our mind and advance past accepted standards to reach our goals.

NOTES

1. Stephanie Clifford, "For Photographers, the Image of a Shrinking Path," *New York Times*, 29 March 2010.

2. Kurt Soller, "An Awkward Obituary," *Newsweek*, 153.14 (6 April 2009).

3. Facebook Press Room, "People on Facebook," www.facebook.com/press/info.php?statistics

4. "Twitter User Stats Revealed," *Huffington Post*, 30 April 2010. www.huffingtonpost.com/2010/04/14/twitter-user-statistics-r_n_537992.html

5. Henri Cartier-Bresson, qtd. in www.hackelbury.co.uk/artists/cbresson/hcb.html

6. Robert Adams, *Beauty in Photography: Essays in Defense of Traditional Values* (New York: Apeture, 1981), 15.

7. Beaumont Newhall, *The History of Photography*, 5th ed. (New York: The Museum of Modern Art, 1986), 27–39.

8. Roy Meredith, *Matthew Brady's Portrait of an Era* (New York: W.W. Norton & Company, 1982), 29.

9. Naomi Rosenblum, *A History of Women Photographers* (Paris, London, New York: Abbeville Press, 1994), 308.

10. Thomas Michael Gunther, "The Spread of Photography: Commissions, advertising, publishing", *The New History of Photography*, ed. Michel Fritzot, English ed. (Cologne, Germany: Konemann, 1998), 555.

11. Rosenblum, 299–300.

12. Rosenblum, 291.

13. James R. Mellow, *Walker Evans* (New York: Basic Books, 1999), 107–110, 624–625.

14. Russell Miller, *Fifty Years at the Front Line of History, Magnum* (New York: Grove, 1997).

15. Robert Adams, *Why People Photograph* (New York: Apeture, 1994),16.

16. Seth Godin, *Free Prize Inside* (New York: Penguin, 2004), 3–4.

17. Godin, *Free Prize Inside*, 5.

18. Chris Anderson, *The Long Tail,* 2nd ed. (New York: Hyperion, 2008), 52.

19. Clifford.

20. Charles Abel, *Professional Photography for Profit* (New York: Greenberg, 1946), 6.

21. "Getty Images and Flickr Announce Exclusive Partnership to Offer New Collection of Creative Imagery," gettyimages.com, last modified 8 September 2008. http://company.gettyimages.com/article_display.cfm?article_id=180

22. Chris Anderson, *Free: The Future of a Radical Price* (New York: Hyperion, 2009), 230.

23. Seth Godin, *Meatball Sundae* (New York: Penguin, 2007), 139.

24. Leslie Burns, *Tell the World You Don't Suck: Modern Marketing for Commercial Photographers* (San Diego, CA: 2008), 14–15.

25. Judy Herrmann, "Here's a Question for You: How Many Clients Do You Need," *ASMP Strictly Business Blog*, www.asmp.org/strictlybusiness, 25 Nov. 2009.

26. Nancy E. Wolff, *The Professional Photographer's Legal Handbook* (New York: Allworth, 2007), 77.

27. Siva Vaidhyanathan, *Copyrights and Copywrongs* (New York: New York University Press, 2001), 21.

28. Wolff, 113.

29. Lawrence Lessig, "For the Love of Culture," *The New Republic*, 4 Feb. 2010.

30. Lawrence Lessig, *Remix: Making Art and Commerce Thrive in the Hybrid Economy* (New York: Penguin, 2008), 244.

31. William Patry, *Moral Panics and the Copyright Wars* (Oxford: Oxford University Press, 2009), Kindle e-book, location 229–36.

32. Susan Carr, "Licensing and Pricing Basics", *The American Society of Media Photographers (ASMP) Professional Business Practices in Photography* (New York: Allworth, 2008), 3–20, 26–30.

33. Ken Auletta, *Googled: The End of the World as We know It* (New York: Penguin, 2009), 315.

34. Auletta, 237.

35. Adams, *Why People Photograph*, 179.

36. Witold Rybczynski, *Looking Around: A Journey Through Architecture* (New York: Viking Penguin, 1992). 8.

37. Adams, *Why People Photograph*, 29.

38. Patry, Kindle e-book, location 229–36.

39. Wolff, 204.

40. Burns, 146.

41. Seth Godin, *Meatball Sundae* (New York: Penguin, 2007), 6.

42. Blake Discher, "You Need to be a Salesperson First", *ASMP Strictly Business Blog*, www.asmp.org/strictlybusiness, 6 May 2010.

43. Richard Sennett, *The Craftsman* (New Haven, CT: Yale University Press, 2008), 172.

44. James Elkins, *Why Art Cannot Be Taught* (Urbana and Chicago: University of Illinois Press, 2001), 20.

45. Sennett, 149.

46. David Bayles and Ted Orland, *Art and Fear* (Santa Barbara, CA: Capra Press, 1993) 59.

47. Rosenblum, 299.

48. *1978 Photographer's Market*, Ed. Melissa Milar and William Brohaugh (Cincinnati, OH: A Writer's Digest Book, 1978), 5.

49. Auletta, 16.

50. Sennett, 21.

51. Nicholas Carr, "Chaos Theory," *Wired Magazine* (June 2010).

52. Bayles and Orland, 49.

53. Lewis Hyde, *The Gift: Imagination and the Erotic Life of Property* (New York: Random House, 1979), 276.

INDEX